IMAGES
of America

REVISITING
SEAL HARBOR AND
ACADIA NATIONAL PARK

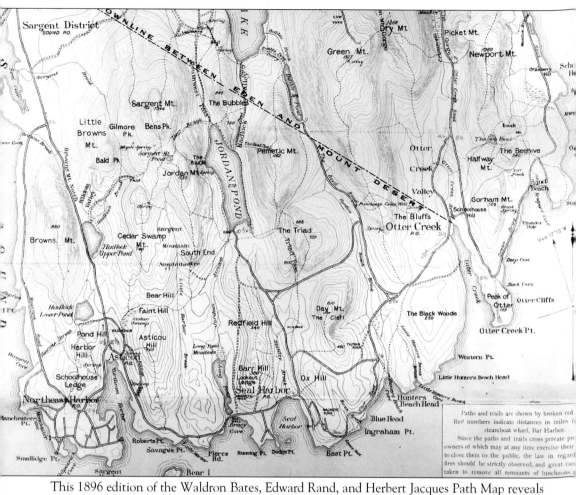

This 1896 edition of the Waldron Bates, Edward Rand, and Herbert Jacques Path Map reveals the extensive network of trails on Mount Desert Island developed by residents and visitors by the beginning of the 20th century. Seal Harbor, an inlet surrounded by lowlands to the west and a granite ridge to the east, can be found at the base of the map. (Maine Historic Preservation Commission.)

IMAGES
of America

REVISITING
SEAL HARBOR AND
ACADIA NATIONAL PARK

Lydia Vandenbergh and Earle G. Shettleworth Jr.

ARCADIA
PUBLISHING

Published by Arcadia Publishing
Charleston, South Carolina

Printed in the United States of America

Library of Congress Catalog Card Number: 2005925449

For all general information contact Arcadia Publishing at:
Telephone 843-853-2070
Fax 843-853-0044
E-mail sales@arcadiapublishing.com
For customer service and orders:
Toll-Free 1-888-313-2665

Visit us on the Internet at www.arcadiapublishing.com

Dedicated to the photographers who made this book possible:
I.T. Moore, Henry Rowland, Ralph Liscomb, Walter K. Shaw Sr.,
Mary Dows Dunham, Edward Dunham Jr., Caroline Bristol Dana,
Eugene Bristol, Charles A. Townsend, George Stebbins,
Lyda Carter Noyes, Ida Berdan Bodman,
George Hadlock, and A. Neal Lane.

Harbor seals, frolicking off the coast of Mount Desert Island, are remembered not only in the name for Seal Harbor but also in the form of logos such as this one. (Maine Historic Preservation Commission.)

CONTENTS

BIBLIOGRAPHICAL NOTE

Amory, Cleveland. *The Last Resorts*. New York: Harper & Brothers, 1952.

Hansen, Gunnar, ed. *Mount Desert, An Informal History*. Town of Mount Desert, Maine, 1989.

Jensen, Jens. *Siftings*. Baltimore: Johns Hopkins University Press, 1990.

Morison, Samuel Eliot. *The Story of Mount Desert Island*. Boston: Little, Brown & Company, 1960.

Newall, Nancy. *A Contribution to the Heritage of Every American*. New York: Alfred Knopf, 1957.

Roberts, Ann Rockefeller. *Mr. Rockefeller's Roads*. Camden, Maine: Down East Books, 1990.

Sherman, W.H. *Sherman's Guide to Bar Harbor and Mount Desert, Maine*. Portland, Maine: W.H. Sherman Publishers, 1892.

Street, George A. *Mount Desert, A History*. Boston: Houghton Mifflin, 1905.

St. Germain, Tom and Jay Saunders. *Trails of History*. Bar Harbor, Maine: Parkman Publications, 1993.

Sweetser, M.F. *Chisholm's Mount Desert Guide Book*. Portland, Maine: Chisholm Brothers, Publishers, 1888.

Sweetser, M.F. *Picturesque Maine*. Portland, Maine: Chisholm Brothers, 1880.

Wilmerding, John. *The Artist's Mount Desert*. Princeton, N.J.: Princeton University Press, 1994

Newspapers: *Mount Desert Herald, Bar Harbor Record,* and *Bar Harbor Times*.

INTRODUCTION

"The mountaineer, the trout-fisher, the hunter, the yachtsman, the artist, the historian, the dreamer; each may find that which suits his taste [on Mount Desert Island], in spite of the dog-day fogs and the storms from the Bay of Fundy." (M.F. Sweetser's *Picturesque Maine*, 1880, p. 43.)

Fishermen hauling cod and haddock from Acadian waters before 1800 boasted of the their plentiful catches. That news reached the ears of John Clement of Bucksport, Maine. A cooper by trade, John Clement recognized the favorable prospects and, in 1808, sailed to Little Cranberry Island across the Eastern Way from Mount Desert Island to build barrels. Mount Desert's safe harbors, its large stands of hardwood, and the numerous brooks appropriate for milling operations impressed Clement. The following year, he returned to Bucksport and moved his wife and family to become the first settlers in a little cove on the south side of the island, now known as Seal Harbor.

Initially, Clement built his cooper's shack on the sandy beachhead, and his log cabin, at one point, lay on the eastern promontory called Ox Hill, a solid granite ridge reaching to the harbor's entrance. The harbor's western point, a low area of woods and fields, narrowed to a point with a small bald island offshore, known as Thrumcap. Northward from the beach ran a deep verdant valley, shielded on both sides by 1,000-foot mountains.

The first years were difficult. The War of 1812 disrupted trade and, just as the outlook brightened, fire destroyed Clement's modest home, "except for one bed," on June 14, 1817. Clement's account book makes clear, however, that he was determined to make his living on the island. Besides coopering, he mended shoes, repaired boats, inspected and packed fish, worked at a local mill, hauled wood, fished, and provided a week's board for Jacob Linvet in 1828 for $1.50. His three sons, James, Jacob, and Amos, inherited his tenacity and, after his death in 1837, continued fishing and producing pogy oil—though Jacob died soon after his father, and Amos eventually left the island for the western territories.

By the late 1860s, the Seal Harbor area, known at that time as Long Pond, had three small settlement clusters. Stephen Southard's store, blacksmith William Callahan's home, and a schoolhouse stood between the head of Bracy's Cove and Long Pond. Farther eastward, the Bracy, Dodge, and Smallidge family homes nestled amongst the trees of Seal Harbor's western promontory and two Clement homes bordered the harbor's sandy beach. James Clement, the eldest son of John Clement and a fishermen by trade, watched a burst of tourism create a lucrative business environment in the neighboring towns of Bar Harbor and Southwest Harbor and thought that his town could attract its share of profits. By 1875, James Clement and his sons had quit the fishing business, remodeled their old farmhouse at the base of the harbor, and announced that they were prepared to entertain summer tourists. Within a few years, their modest dwelling with housing for 10 boarders provided them with $100 weekly in the summer months, a sizable income in those days. "Uncle Jimmy," as the elder Clement was called, expanded the hostelry, managing it with his sons James Jr. and Amos. Sons John and Charles also helped with the venture, and later Charles Clement started his own Petit Hotel to absorb the overflow of tourists.

Just as fishermen's stories had been the early advertisements for the island, a handful of artists, poets, and journalists seeking new inspiration for their work took paintbrush and pen to depict the island's untamed forests and rugged landscapes. The poet Whittier expressed his views in verse: "They seek for happier shores in vain, Who leave the summer isles of Maine," and a journalist for *Harper's New Monthly Magazine* gave a full description of the island, which concluded that "in all my wanderings I remember no place where the lover of the beautiful, the romantic, and the more sublime elements of nature will find so much that will fascinate and captivate him as here." Few Victorians could resist such panegyrics.

The wildness of the island attracted city dwellers who, influenced by Thoreau's philosophy, were anxious for ways to reverse the trend of industrialization. Called rusticators by the natives, these pleasure seekers flocked to the island seeking simple accommodations. As Newton's Law of Resorts aptly predicted: "For every fashionable resort, there is, close by, another less fashionable [one] which has grown up as a reaction." (Cleveland Amory's *The Last Resorts*.) Seal Harbor fits this prediction perfectly. In contrast to Bar Harbor's social formality, fast pace, and busy schedules, the neighboring resorts of Seal Harbor and Northeast Harbor deliberately attracted academicians seeking an intellectual atmosphere, outdoor activities, musical entertainment and, in short, a quieter social milieu. These educators, the largest groups drawn from Harvard and Yale, summered at the hotels, congregating to talk, explore the origins of brooks, or add new paths to the existing labyrinth of woodland trails. The term rusticator was not unique to this era. In 1789, Triumphs Fortitude described the term in these words: "Wherever those of the fashionable world assemble, in spite of all they can do to rusticate, Art will generally appear to prevail over Nature."

The prospering little town of Seal Harbor drew notice, not only from mainland people who came to open stores and service businesses but also from George Cooksey, a wealthy New York grain merchant who saw an opportunity to summer in a beautiful place while making a profit on developing the harbor's eastern promontory. Cooksey, in turn, coaxed relatives and business associates into building cottages in Seal Harbor, thus initiating the transition from a resort of hotel boarders to one with a mixture of inn guests and cottagers. These new rusticators sought not only to be surrounded by nature but also to live in their own comfortable, stylish homes.

George Cooksey's cottage "Glengariff" set the direction for much of Seal Harbor's summer architecture during the next four decades. Cooksey chose to build in the popular Shingle style, a reinterpretation of New England vernacular forms expressed in stone and shingles and sited to blend into the coastal landscape. In contrast to neighboring Northeast Harbor, where local architect Fred Savage designed 70 cottages for Bostonians and Philadelphians, Seal Harbor's New Yorkers patronized their own firms, employing designers such as Isaac H. Green Jr., Carrere and Hastings, Grosvenor Atterbury, and Duncan Candler. In both summer colonies, the landscape architect of choice was Beatrix Farrand, a Bar Harbor summer resident whose work ranged from the intimate gardens for the Dunham, Bristol, and Herter families to her masterful fusing of oriental and western themes on a larger scale for Abby Aldrich Rockefeller's garden at the "Eyrie." A talented local work force of carpenters and masons, among them the Smallidges and Candages, implemented the architects' and landscapers' plans.

The island's terrain and heritage had the greatest influence on the cottage nomenclature. George Stebbins, a Seal Harbor realtor, asked advice on naming a new cottage from John Snow, one of the few remaining Native Americans to live on the island. He was told, "You know Mr. Stebbins, in our language, we can't name anything without a reason. So, tell me something about the house." Stebbins replied that it was on the upper road, farthest east of all the houses on the hill. Snow stopped Stebbins there and stated that "Wabenaki," meaning farthest east in the Penobscot tribe's dialect, would be suitable. Similarly, the cottage "Keewaydin" was named for the site's prevailing west winds. Christian Herter chose the Spanish word "Miradero," meaning vantage point, as a suitable description for his home perched on Ox Hill's crest. Other cottage names, such as "Edgecliff," "Craigstone," "Overlook," and "Eastholm" reflected the area's topographical characteristics or the home's orientation.

At the beginning of the 20th century, the island's mountains also had titles mirroring the terrain and landowners. Green Mountain, the island's highest peak, took its name from the appearance its forests gave from the sea, whereas the title for Jordan Mountain recalled George and John Jordan, the lumbermen who settled there in the mid-1800s. As these and the other 13 mountains became part of the Sieur de Monts National Monument and, later, Lafayette National Park, the U.S. Department of the Interior changed the nomenclature, paying tribute to other settlers and pioneers. Green Mountain became Cadillac, commemorating Sieur de Monts Cadillac, the French statesman who sponsored Champlain's famous voyage in 1604, in which he sighted and named the island Isle de Mont Deserts. Jordan Mountain became Penobscot, honoring one of the Native American tribes inhabiting the island in the years before the French and English fought over the area. Both the park's initial name, Lafayette, and its later title, Acadia, reflected the bond between the United States and France, with the latter term representing the area's original French name. The islanders' reaction to these politically motivated changes exemplifies the paradox of feelings about the park's creation. Some accepted modifications to their island's landscape, recognizing its economic benefit to the region; others resented this interference from Washington and resolutely clung to the old names.

Controversies arising from diverging philosophies also flared during periods of the park's development. Initially, a united effort led by Northeast Harbor's Charles Eliot, Bar Harbor's George Dorr, and Seal Harbor's George Stebbins created a land trust to protect the island's forests from lumber companies and land speculators. Between 1903 and 1916, publicly spirited citizens donated over 5,000 acres, primarily mountaintop, to this trust. Recognizing the trust's limited resources for maintenance, Eliot and Dorr successfully convinced the federal government to accept its holdings for a national monument, which later became Lafayette National Park. This transition from a private reservation to a public park parallels the two polarized philosophies that emerged at this time: exclusivity versus accessibility. Eliot, an avid outdoorsman who fondly remembered the days of unrestricted hiking over the entire island, advocated that access to the innermost regions of the park should be reserved for those willing to make an effort on foot. Dorr, who had once supported this view, shifted and joined Seal Harbor resident John D. Rockefeller Jr. to endorse broader access to all regions of the park. Consistent with this belief, Rockefeller built a network of carriage roads and, later, motor roads, which he subsequently donated to the federal government, becoming the park's greatest benefactor.

The park and surrounding lands were a natural attraction to prominent people. Charlotte Rhodes Hanna, widow of Ohio Sen. Marcus A. Hanna, built her home in Seal Harbor. Soon afterward, with great effort, she arranged a visit from Pres. William Howard Taft. When he arrived on a rainy day in 1910, his large yacht *Mayflower* had to moor outside the cove. A small launch brought the president and his entourage to the steamboat wharf float, where a large committee, including Charlotte Hanna, waited under a cloud of umbrellas. Taft, with his portly 300 pounds, stepped onto the corner of the floating dock, which tipped beneath the water. Innocent aides rushed to his side, making the float sink deeper, until sea-wise committee members came to the rescue. Fortunately, Charlotte Hanna's fancy Victoria carriage was poised by the wharf, ready to take her and the president up the hill to dry their feet by the fire. Newsmen and photographers left the description of this notable event to the storytellers.

By the 1920s, Seal Harbor was a lively resort, populated by a coterie of professors, ministers, artists, and businessmen—the latter group slowly displacing the others. As Seal Harbor's Old Guard of educators died, a new group of families chose the serene resort for their summer home, including Edsel Ford and his kin. Reflecting social patterns of the times, cottagers built exclusive clubs, separating themselves from the islanders.

The depression years were a time of retrenchment. Consistent home construction and repair work, which the old cottages had once provided, was no longer. Those rusticators less affected by the depression helped the island's threatened economy by continuing to patronize the shops and restaurants. Edsel Ford still could be found dining in his small private room at the Jordan Pond House, and John D. Rockefeller Jr. increased the pace of road building in the park. Some

islanders were fortunate to hold jobs working on the roads or as caretakers for wealthy cottagers. Others left for the mainland.

Though the three-week fire of October 1947 destroyed 70 of Bar Harbor's 222 stately mansions and spared Seal Harbor, it brought a climax to decades of change in this community. The future for the sprawling cottages, built in an era of large household staffs and low taxes, had dimmed as property values declined, income taxes soared, servants became scarce, and vacations shortened. A few families opened their expansive cottages to selected paying guests, reviving a tradition of the 1880s, but this economic ploy failed. Finally, many of the cottages were sold for taxes, some were razed, and a handful remained under family ownership. The community's ability to adapt to changing lifestyles and economics can be attributed to its diverse assortment of cottages, varying in style as well as size and built on a smaller scale than those of neighboring Bar Harbor.

What remains today are monuments—cottages, community buildings, and Arcadia National Park—that serve as reminders of collaborative efforts between the islanders and the summer sojourners. As Rev. George S. Brookes wrote for the dedication of Seal Harbor's Neighborhood Hall in 1919: "While New Yorkers look with admiration upon the Statue of Liberty . . . and Bostonians are justly proud of Bunker Hill . . . Seal Harborites are able to offer to an increasing number of visitors the permanent attractions of mountain, hill and dale, pond, river, and sea. Our monuments . . . are found in beautiful homes, some of which are memorials of self-sacrifice and faithful, untiring devotion of men and women." This book pays tribute to these monuments and their creators.

One

FROM FISHING
TO TOURISM:
1870–1893

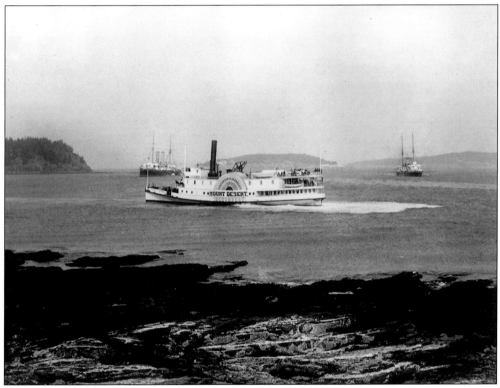

Steamers such as the side-wheeler *Mount Desert* spurred the tourist trade on Mount Desert Island. With initial connections between only the mainland ports of Rockland and Portland to Southwest Harbor and Bar Harbor, other destinations were reached by buckboards, sailboats, and rowboats. The *Mount Desert* inaugurated Seal Harbor's first steamboat pier in 1882. However, it was more than a decade before this community's residents could rely on daily landings. (The James D. Clement family.)

In 1888, M.F. Sweetser wrote of Seal Harbor in *Chisholm's Mount Desert Guide Book:* "Beyond the environs and the influence of Bar Harbor, the island of Mount Desert has several other watering places. They are at once less expensive, less luxurious, and less artificial than Bar Harbor, and enjoy greater nearness to unspoiled nature, greater quiet, and more freedom from conventionality." These qualities were captured by photographer Henry Rowland in this dramatic image with Seal Harbor in the distance. (Seal Harbor Library.)

The natural beauty of Mount Desert's hills and mountains appealed to the romantic spirit of Hudson River School artists such as Thomas Cole and Frederick Church, whose paintings gave pre–Civil War Americans their first glimpses of the island's dramatic scenery. Late-19th-century photographers, such as Seal Harbor cottager Henry Rowland, continued this landscape tradition. The rugged topography that Rowland's photograph depicted in the 1890s was aptly described in the following period guidebook account of Seal Harbor: "Wooded hills and valleys extend from the shores of the harbor inland to the mountains. The invigorating effect of the pure salt sea air, mingled with the fragrance of the balsam-fir and pine, gives new life to drooping energies." (Seal Harbor Library.)

The Jordan Pond House, shown here in 1898, attracted resorters to its dining room for afternoon tea and prepared picnics. In the three short years that they had managed the teahouse, the McIntires had already made it a popular destination. Nellie McIntire contributed popovers and ice cream to the menu, while Thomas McIntire, a carpenter, added a small dining room and a wide veranda to the rustic farmhouse. The house derived its name from its original owners, John and George Jordan, millers. (Northeast Harbor Library.)

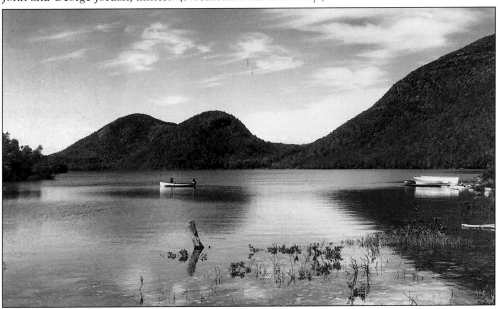

From the Jordan Pond House, visitors looked out upon the serenity of the pond, which terminated in the twin peaks known as the Bubbles. This 1890s view by photographer Henry Rowland brings to life M.G. Sweetser's description of the scene in *Chisholm's Mount Desert Guide Book:* "We come out on Jordan's Pond, the loveliest of all the Mount-Desert lakes. It is but a mile and a quarter long, with a width of about a quarter of a mile, but the shores are mantled with the richest green frondage, and on all sides rise noble and picturesque mountains." (Seal Harbor Library.)

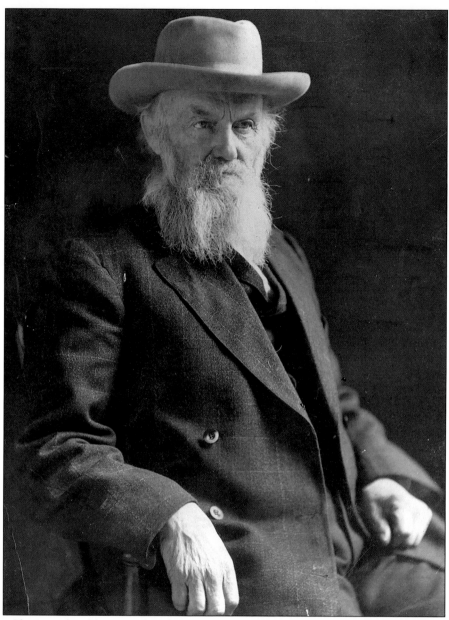

James Clement, the eldest son of Seal Harbor settler John Clement, followed his father's trades in fishing, coopering, and operating mills. In the 1860s, the decline of the fishing and pogy oil industries was counterbalanced by the rise of the tourist trade. Though in his sixties, James Clement, known as "Uncle Jimmy," would not allow Seal Harbor to lie idle. Thus, c. 1870, he and his wife, Abigail Southard, along with their daughter, Sara, and their sons, John, James Jr., Amos, and Charles Henry, modified their home to accommodate boarders. By the time he died in 1887, Clement had watched his sons Amos and James Jr. become the proprietors of the Seaside House, his son Charles start his own hotel on the harbor's eastern side, and his cousin Alanson Clement establish a livery service. The tiny hamlet was well on its way toward becoming a resort to provide a stable livelihood for these former fishermen. (The James D. Clement family.)

14

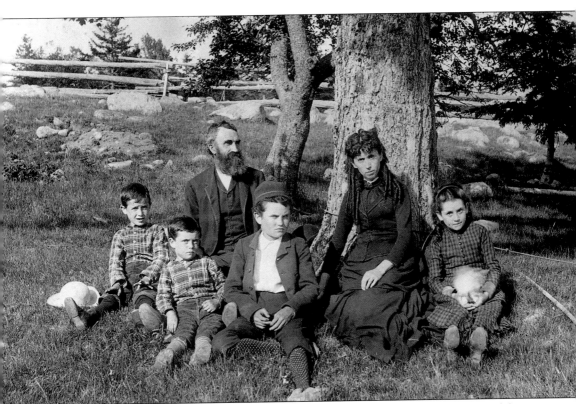

Although Charles Henry Clement was raised by his father, James Clement, as a Maine fisherman, he was already an experienced hostler by the time of his marriage to Sarah Thompson in 1876. The couple built a home just above the harbor's eastern shore to raise their four children, (shown, from left to right) Irving, Frank, Arthur, and Eva Clement. A 12-room addition later turned the home into the Petit Hotel (later renamed the Seal Harbor House), renowned among the rusticators for its comfort and the cordiality of the proprietor. By the time of his death in 1932, this enterprising Clement had not only raised the livestock for his inn's table but also marketed fish for both local and Boston buyers and managed the American Express freight office as well. (The Liscomb family collection.)

The evolution of the Seaside House from a private residence to a major summer hotel reflects a trend found along the Maine coast in the post–Civil War era, as local families used their entrepreneurial skills to accommodate a growing number of summer visitors. The Clement family enlarged this modest home into the 10-room boardinghouse c. 1870. Guests, primarily from Philadelphia and Baltimore, paid $10 a week per room. (The James D. Clement family.)

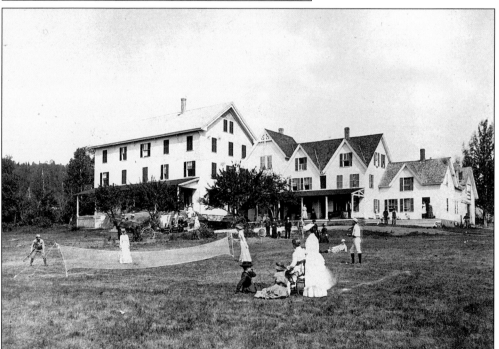

Fashionably dressed women enjoy watching a tennis match on the lawn in front of the expanded Seaside House on a summer day in the 1880s. In 1882, the Clement family attached a three-and-a-half-story annex to the left side of their original hotel, thus providing another 30 rooms, with individual rates ranging from $7 to $10 dollars per week. (The James D. Clement family.)

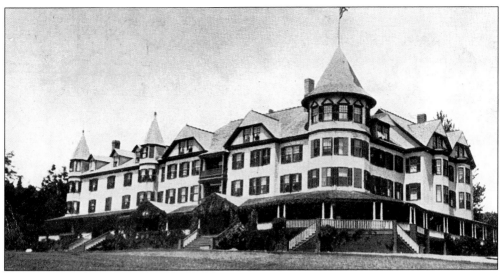

In 1891, Amos and James Clement hired the Bar Harbor architect and builder John E. Clark to transform the Seaside House into a grand Queen Anne–style summer hotel, which they renamed the Seaside Inn. The original residence and boardinghouse were moved back, and the 1882 annex was incorporated to the left of this picturesque new structure, featuring a 150-foot-long veranda across the front and a 100-foot-high tower at the corner. Two smaller towers framed the annex, while four large gable-roofed dormers highlighted the roofline of the main building. (Maine Historic Preservation Commission.)

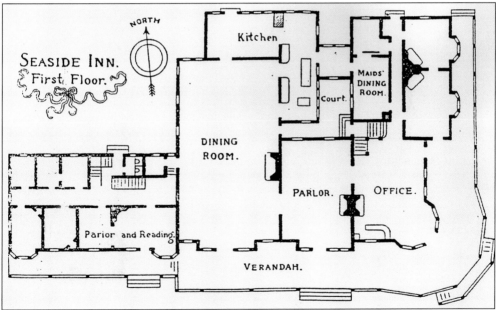

When the Seaside Inn opened for the 1892 season, guests reveled in the spacious hotel facilities, previously unknown in Seal Harbor. Architect John E. Clark's new first-floor plan provided for a 27-by-37-foot office or lobby, a 27-by-32-foot parlor, and a 38-by-65-foot dining room. Behind these three public rooms were service areas, such as the kitchen and the maids' dining room. Part of the 1882 annex was devoted to a second parlor and reading room. (Stephen C. Clement.)

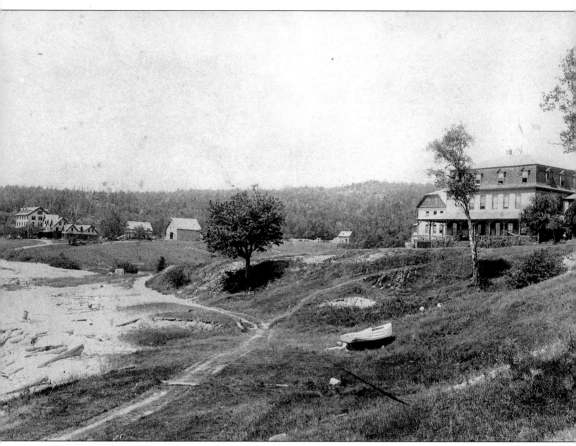

Ever since the painter Thomas Cole visited in the 1840s, the Lynam family had boarded guests at their Schooner Head homestead. Some 40 years later, Capt. Edwin V. Lynam, in partnership with his son-in-law Robert Campbell, erected a two-story hotel with a mansard roof overlooking the Seal Harbor beach. This Glencove Hotel opened in 1884 to offer 24 rooms for rusticators at $10 per week. The flourishing tourist trade three years later encouraged the proprietors to build a four-story annex. The topography required an elevated 150-foot bridge, dubbed the Hyphen, to span a glen and link the two buildings. This addition was designed to appeal to the hotel's intellectual patrons: a 130-seat dining room was supplemented by a reading room and a sizable music room, which became popular at all seasons. In the music room, summer visitors enjoyed dances, church fairs, and plays by the local drama club. In the wintertime, the room was livened by dancing lessons, masquerade balls, progressive euchre card parties, and church socials. (The James D. Clement family.)

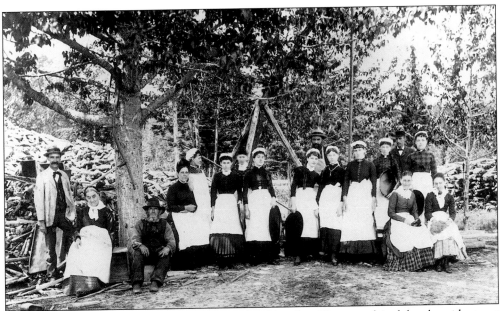

As the hotel business expanded in the mid-1880s, the Clements hired local residents as chambermaids, cooks, waiters, and laundry maids. The size of this staff did not preclude the family from working. Even into their eighties, Seaside Inn founders Abigail and James Clement (seated at left) could be found in the cook house, preparing the three-meal fare offered guests daily, or out back, adding to the mammoth woodpile needed to stoke the cooks' and laundry maids' fires. (The James D. Clement family.)

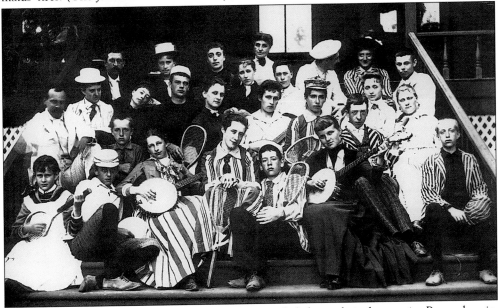

Many of Seal Harbor's first summer visitors traveled from their homes in Pennsylvania, Connecticut, and Massachusetts to spend several weeks enjoying hiking expeditions to the island's ponds, valleys, and mountains; daylong buckboard excursions; and tennis games. In the evenings, energetic youth filled the hotels' dance halls for an informal hop or music recital. The Seaside House's front steps offered a perfect spot for a posed picture. (Walter K. Shaw Jr.)

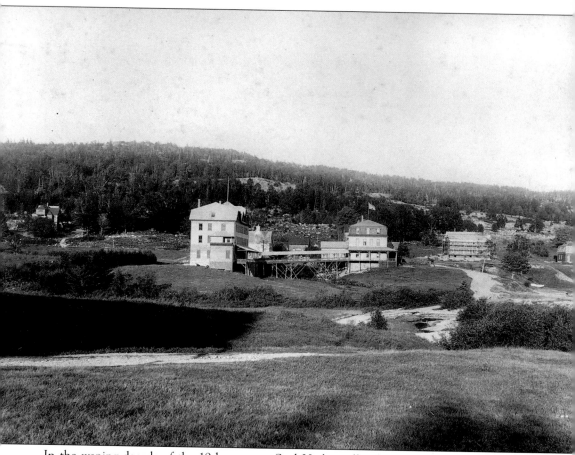

In the waning decade of the 19th century, Seal Harbor offered an idyllic vacation. Its three hotels, the Seaside Inn, the Glencove Hotel (center), and the Petit Hotel (far right) ringing the beach could accommodate 200 guests, "those who wish to avoid the fashionable gaiety and bustle of Bar Harbor and lead a life of calm pleasure amid beautiful scenery," according to the proprietors. Natives catered to every rusticator's whims. With cod and haddock plentiful, Eastman Dodge rented boats and fishing gear; the Jordan Pond House rented canoes and rowboats for the ponds clear waters, with tea on the lawn to follow; for carriage rides to the top of Green (Cadillac) Mountain, or moonlit buckboard serenades, Alanson Clement and the Lynams ran stables near the Glencove Hotel. Woodland walks, picnics, and regattas all appealed to refugees from stifling eastern cities, while foggy days or quiet afternoons called for excursions to local stores for newspapers and stationery. Fundamental to rising patronage were the summer telephone connection to Seal Harbor in 1885 and especially the concurrent railway extension to Mount Desert Ferry, across the Frenchman's Bay from Bar Harbor. Within two years, more than 24,000 visitors, twice that of previous years, came to the island. (The Liscomb family collection.)

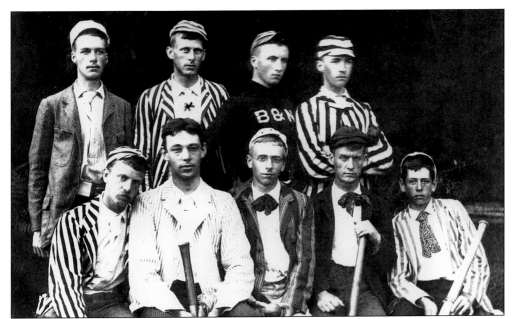

The rage for baseball brought together Seal Harbor's summer boarders and winter residents. Winchester Noyes, a longtime summer resident of the community, recalled that "Baseball was the serious sport of the time. Each town had its own baseball league and we had one or two official games every week, practice every other day. Our field was on Cranberry Island. When there was a breeze, we sailed over, otherwise went in a barge, a huge rowboat . . . two oars on each side, and we rowed over." (Walter K. Shaw Sr.)

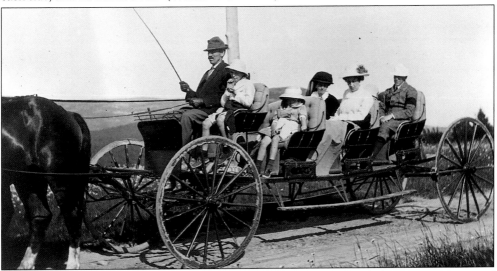

Carrying up to 12 passengers, the Bar Harbor buckboard remained the primary means of transportation on the island until a ban on automobiles was lifted in 1915. Whether meeting the steamer or providing the summer visitors with leisurely rides to the island's attractions, everyone depended on these locally made wagons. One visitor fondly recalled that she and her friends, clad in flowing dresses, took a half-day "drive up Beech Hill, saw the sunset, suppered at the Somes House, and returned by moonlight, all singing lustily." (The Dunham family collection.)

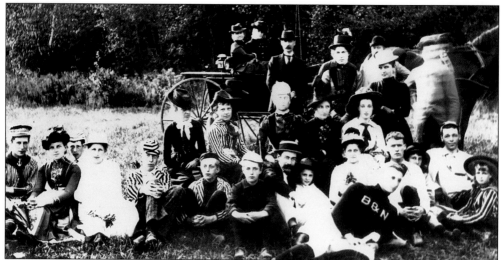

The Tip Top House at the summit of Green (Cadillac) Mountain was a popular destination for Seal Harbor's boarders. Hikers would take a steamer to Bar Harbor, trek up the mountain and down, and get a buckboard lift home. The following poem by Seal Harbor cottager Walter K. Shaw Sr. tells of Mrs. Clement's maternal advice to her boarders, "When you've clambered down the mountain, And the Frenchman's camp do reach, Take the buckboard by the fountain, Which we'll send there, we beseech." (Walter K. Shaw Sr.)

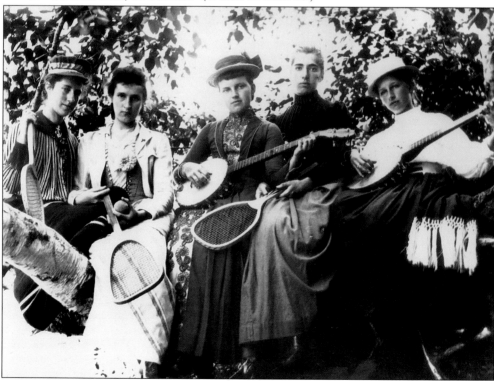

These women of 1889, outfitted in long-sleeved blouses, ankle-length skirts, and jackets are well prepared for some tennis on the Seaside Inn lawn, or perhaps a banjo recital in the hotel's music room—popular day and evening diversions. (Walter K. Shaw Sr.)

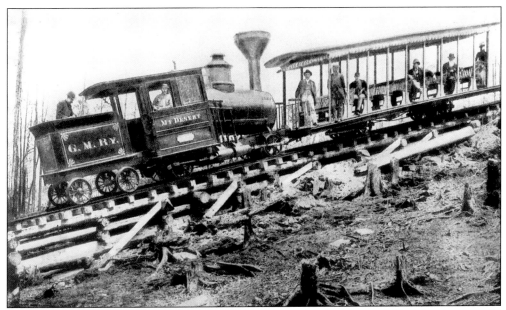

Since the 1930s, the summit of Cadillac Mountain in Acadia National Park has been easily accessed by automobile but, in the 1880s, the journey to the top of what was then known as Green Mountain was more challenging. By 1883, tourists were taken from Bar Harbor by carriage to Eagle Lake, where they boarded a steamer that transported them to a cog railway at the base of the mountain. Ascending the mountain in an open car, visitors enjoyed breathtaking coastal and inland views from 1,500 feet above sea level. (Maine Historic Preservation Commission.)

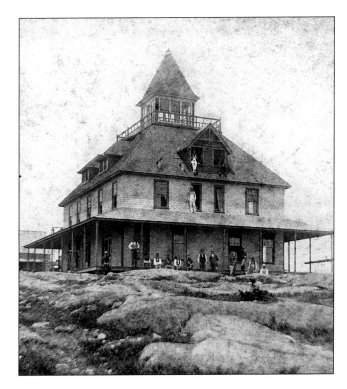

With the building of the Green Mountain Railway in 1883, the simple mountaintop structure that had served earlier visitors was replaced by this impressive hip-roofed Queen Anne–style hotel, known as the Summit House. Designed by the Bangor architect Wilfred E. Mansur, the hotel was built in the spring of 1883. This photograph captures workmen pausing as the construction neared completion. Only a year after it opened, the Summit House was destroyed by fire. (Maine Historic Preservation Commission.)

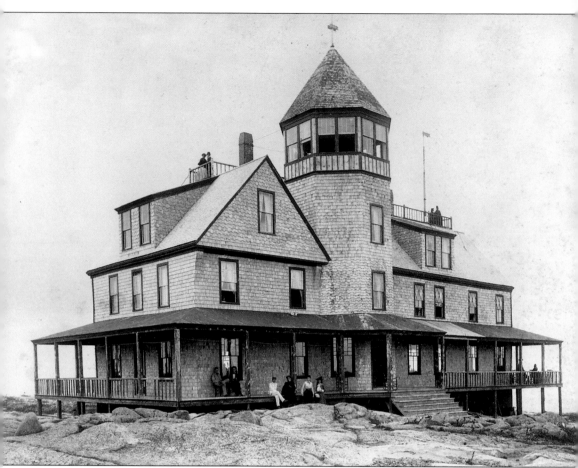

The Summit House was quickly replaced in 1885 by a larger and more picturesque Queen Anne–style hotel, again designed by Bangor architect Wilfred E. Mansur and built by John E. Clark of Bar Harbor. Guidebook author M.F. Sweetser described the second Summit House in 1888 as being "of modern construction, high studded and airy, with twenty commodious rooms, broad encircling piazza, an observatory tower, and a dining-hall where good meals are served at a low figure. The best viewpoint is the cupola, where there is a telescope, with which the remoter objects are clearly identified." Competition from the carriage road to the summit forced the railway into bankruptcy less than 10 years after its initiation. The last evidence of this business endeavor, the Summit House, was torn down in 1896. (Maine Historic Preservation Commission.)

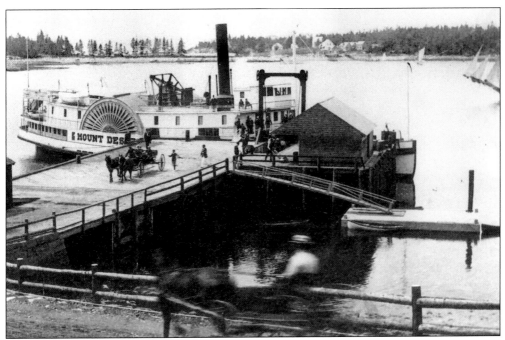

The steamer *Mount Desert*, shown docked at the Seal Harbor wharf in 1885, made regular trips between Rockland and Seal Harbor only once each week, though special landings could be arranged when more than a few persons needed passage. Otherwise, residents and visitors relied on steamer service to Southwest Harbor and Bar Harbor. Freight, especially supplies for cottage construction, could be delivered to the village wharf, though the steamboat companies charged double the normal freight costs for this. (Walter K. Shaw Sr.)

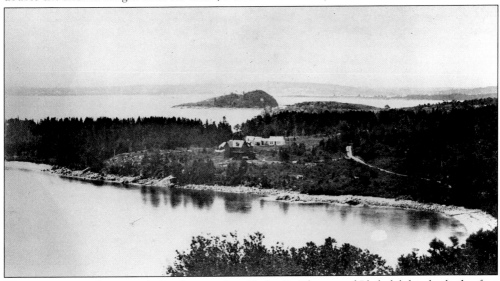

The summer-resident population began when Rufus R. Thomas of Philadelphia built the first cottage, "Stoneleigh," on Seal Harbor's western shore in 1882. Within three years, Cmdr. Arent Crowninshield of Washington, D.C., and L.R. Boggs of Pennsylvania, lured by reasonable land prices, added cottages to the harbor's western lowlands, an area already dotted with native homes. (The Liscomb family collection.)

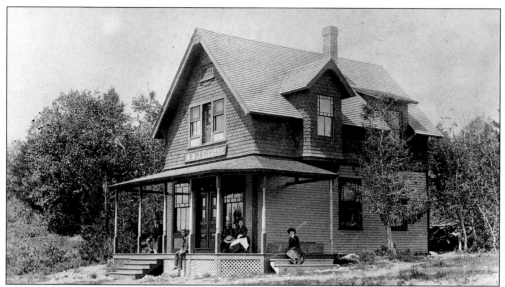

Seal Harbor's hotel era spurred the establishment of a several small businesses in various locations skirting the harbor. Beginning in 1882, the year-round residents and guests no longer had to travel over the hill to Steven Southard's Long Pond store for their groceries, but instead could easily walk from the hotels to Capt. William Cox's general store. Five years later, the Clement brothers, keen to provide their patrons with every convenience, opened this small store by the shore where newspapers, stationery, and sweets were in great supply. (The James D. Clement family.)

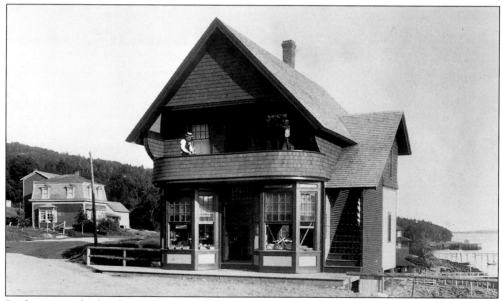

Profit attracted other businessmen as well. Guests of the Petit Hotel (at left) could stroll across the street on a hot afternoon for ice cream and a newspaper at this corner market built by Byron W. Candage for his son Arthur Candage. After a few years, the Candages sold the business for lack of time to Messrs. Freeman and Ober. The new proprietors opened a meat market at the street level and rented the two upstairs rooms in 1898 to the Seal Harbor Union Club, whose members read, played whist, or shot pool there. (Maine Historic Preservation Commission.)

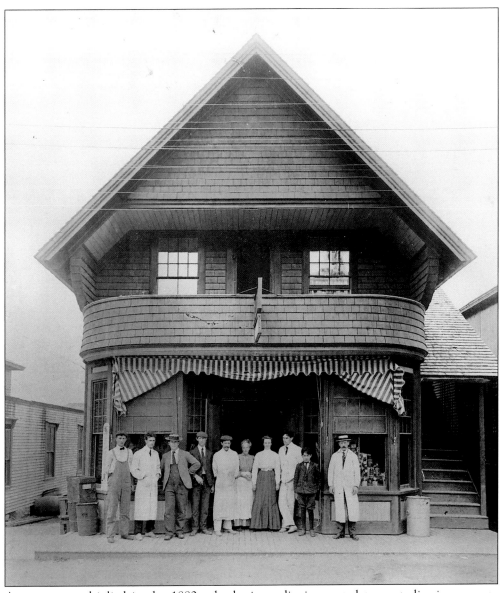

As cottages multiplied in the 1880s, the business district started to centralize in one area north of the harbor's head. Entrepreneurs built new establishments and expanded others. In the case of the Candage market, a new owner moved the building away from the Glencove corner to a new site among other businesses. As the community took on a village atmosphere, economic prosperity spurred specialization. In 1886, Capt. William Cox, owner of the general store and post office, added two floors and broadened his inventory. Clients still found general merchandise on the first floor, but could purchase ready-made clothing and gentlemen's furnishings upstairs. With an eye on profits, almost all the stores either had rooms to rent above the commercial area or housed the proprietor. Such extra accommodations also served to house staff brought in for the busy summer months. Billings Market (above), specializing in quality meats and produce, needed ample help to record and deliver orders, pick produce from its extensive garden behind the Seaside Inn, stock the shelves, and serve demanding customers. (The James D. Clement family.)

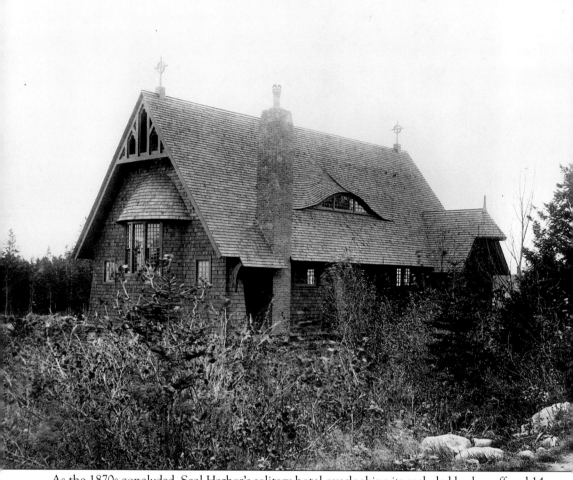

As the 1870s concluded, Seal Harbor's solitary hotel overlooking its secluded harbor offered 14 rooms and an abundance of natural surroundings to those city dwellers seeking a quiet holiday. This scene changed within two decades, though simplicity was still a hallmark. Rusticators overflowed three hotels and eight summer cottages, keeping the local proprietors and staff busy; a burgeoning town spread along the central street; and connection to neighboring towns and the mainland eased with daily mail service and the telephone. All the amenities existed in this perfect resort, save one: a house of worship. The resident population depended on sporadic services at the schoolhouse; summer visitors attended churches in Bar Harbor and Northeast Harbor. In 1887, year-round and summer residents raised over $2,500 to construct an Episcopalian chapel, St. Jude's. The chapel was designed by Boston architect William R. Emerson and was built on land donated by native George Bracy. Town residents liberally donated their labor and funds toward this Shingle-style building, the first of many public spaces built through cooperation between Seal Harbor's permanent and summer residents. With the church complete, the local newspaper correspondent aptly predicted that "a fortune awaits those who have the enterprise to build the needed accommodations." (The Liscomb family collection.)

Two

A Retreat for Academics and Theologians: 1894–1910

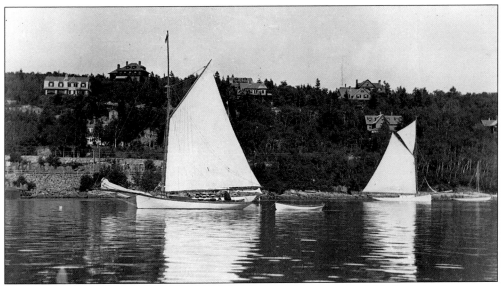

The beginning of the 20th century witnessed rapid change in Seal Harbor's landscape and community. A handful of cottages multiplied to over 40, many of them scattered along Ox Hill, the solid granite ridge rising from the harbor's eastern shore. A new church and several organizations lent structure to social and community activities. Professors, theologians, and scientists were attracted to the resort's quiet milieu, which afforded them an ideal environment for research and writing, together with summer diversions. A few scientists built auxiliary laboratories near their cottages to continue their winter experiments. Summer guests at the thriving hotels and scattered cottages meant prosperity for year-round residents as well. Former fishermen, lumbermen, and their kin were now proprietors and service personnel for the many rusticators. (The Dana family collection.)

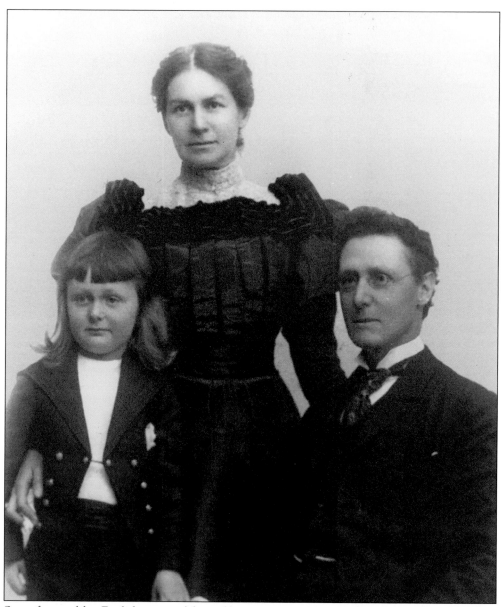

Son of a wealthy Englishman and himself a prosperous New York grain merchant, George Borwick Cooksey (right) was a key figure in the expansion of Seal Harbor. He apprenticed with David Dows and Company, married Mr. Dows's daughter Linda (center) and, swayed by family enthusiasm, bought the harbor's eastern point after his arrival in 1891 at age 34. Envisaging a planned development of Ox Hill, he also bought that eastern ridge for $50,000, which was 50 times its sale price a mere decade earlier. Cooksey's substantial wealth and enterprise created roads, water, and sewer lines sufficient to open up parcels of oceanfront and hillside properties. Between 1891 and 1895, Cooksey achieved only part of the plan. He built the Sea Cliff Drive, at a cost of some $20,000, founded a realty company, improved access to the steamship wharf, sold three lots to college professors, and convinced several relatives to build cottages. This enthusiasm, however, came at a cost. In declining health, he retreated to New York, seldom visiting Seal Harbor before his death in 1922. (Helen Cooksey.)

In 1891, George Cooksey hired architect Isaac H. Green Jr. of Sayville, New York, to design his new cottage "Glengariff" (above), Seal Harbor's first major Shingle-style building. In an 1892 article about this home, the *Bar Harbor Record* described its features: "The first story is built of rough moss-covered stone in exact harmony with the surrounding cliffs. The second story projects over the main wall and rests on rough stone columns forming a piazza, loggia, and covered driveway and is covered with southern cedar shingles." Later, Green returned to design other cottages on Ox Hill. (The Dunham family collection.)

The massive granite arch spanning the deep gorge known as Raven's Nest is just one of the engineering feats Alanson Clement and his crew of 60 achieved in building the Sea Cliff Drive in 1896. The one-and-a-half-mile stretch commissioned by George Cooksey opened up several oceanfront lots and spectacular vistas overlooking the bold promontory Hunter's Beach Head and the low-lying islands offshore. (Seal Harbor Library.)

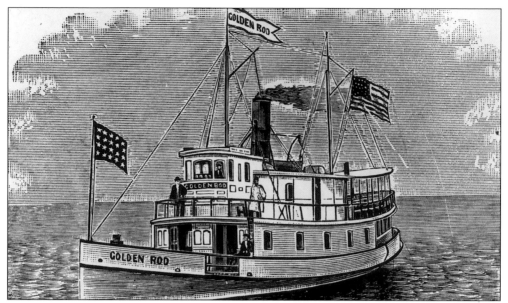

Frustrated by the lack of steamer service, George Cooksey joined in 1893 with other summer residents and hotel proprietors to build the *Golden Rod*. This side-wheeler steamer, commanded by Captain Crosby, ran two daily circuits among the Mount Desert resorts. Once the Island Steamboat Company proved the route profitable, a Bar Harbor firm bought the boat and continued the service into the 1900s. (Great Harbor Collection.)

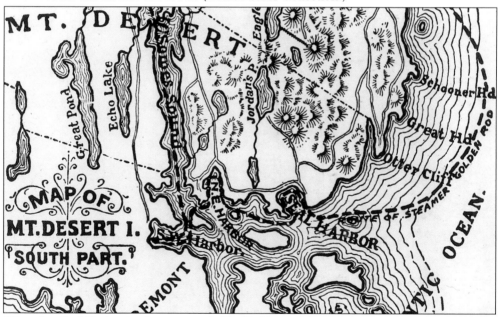

"To sail to Seal Harbor by the steamer *Golden Rod* leaving Bar Harbor at 10 am enables one to obtain views of coast and mountains that can be seen no other way. Arriving at Seal Harbor one hour later, the visitor has 3½ hours before the return of the boat, which may be very pleasantly occupied in seeing the local attractions of the place—Jordan Pond, Ravens Cleft, Ox Hill, the Cliff walk, etc.—with ample time to obtain a good dinner at one of the hotels." (*Bar Harbor Record*, Centennial Souvenir Edition, July 1896.) (Great Harbor Collection.)

The Danas, shown here on an outing along one of Cooksey's roads with the Rowland children, Harriet and Henry Jr., typify summer life in Seal Harbor. Cooksey convinced Yale geologist Edward Dana and Johns Hopkins physicist Henry A. Rowland to join other faculty and churchmen, who together gained for this small resort the reputation as a haven for intellectuals. (Mr. and Mrs. Lewis H. Gordon Jr.)

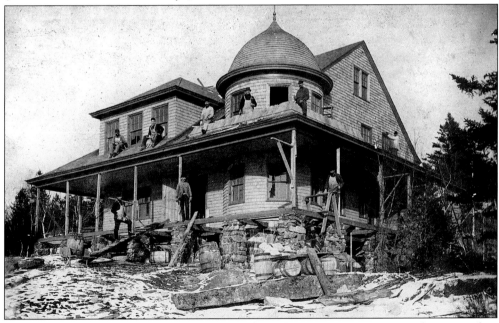

Snow covers the ground during the winter of 1895–1896, as carpenters work to complete "Graycliff" for the coming summer season. Featuring a distinctive corner tower, this Shingle-style cottage was designed by Isaac H. Green Jr. for Yale professor Eugene S. Bristol. Next door, contractors were also finishing a Green-designed home for Bristol's brother-in-law Edward S. Dana, ensuring that both cottages would be ready for the families' summer holidays. (The Bristol collection.)

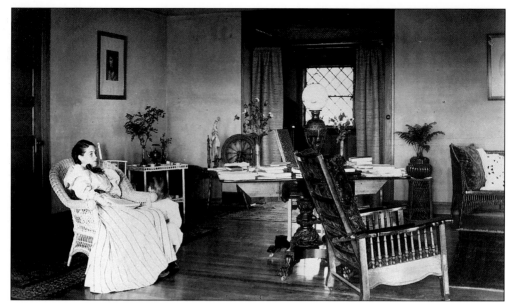

This scene provides a glimpse of life in an 1890s Seal Harbor summer cottage, in this case "Craigstone," built for Henry A. Rowland. It shows his wife, Henrietta Rowland, elegantly attired in a striped white summer dress, reclining in a white wicker chair in the fashionable living room. With its shining pine floors and plain painted walls, the room has a spacious and informal feeling. In the background stands an antique spinning wheel, a hallmark of Colonial Revival taste; an up-to-date morris chair dominates the foreground. (Mr. and Mrs. Lewis H. Gordon Jr.)

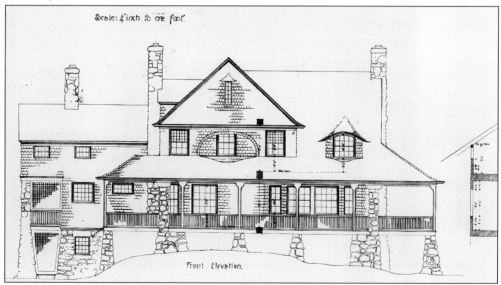

Like the Bristols and the Danas, Henry A. Rowland employed Isaac H. Green Jr. to design his Shingle-style cottage "Craigstone," which was built during the winter of 1895–1896. Rowland had been a physics professor at Johns Hopkins University in Baltimore since 1876. Ironically, though Rowland was internationally recognized as a pioneer in optics technologies, "Craigstone" could not be wired with the newest electrical advances before his death in 1901 because service was not yet available to Ox Hill. (Mr. and Mrs. Lewis H. Gordon Jr.)

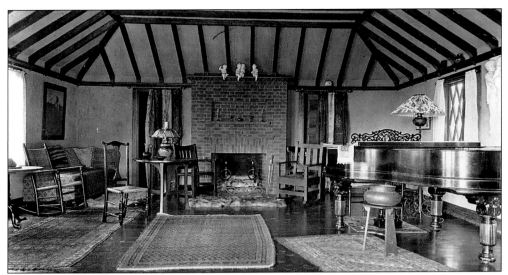

Often, the Bristols and their kin the Danas could be found practicing the piano or listening to an impromptu concert in a small bungalow called the "Music Room." Built by Mrs. Bristol near her cottage "Graycliff," the bungalow helped establish the musical culture that became such an important aspect of the Seal Harbor summer colony. (The Dana family collection.)

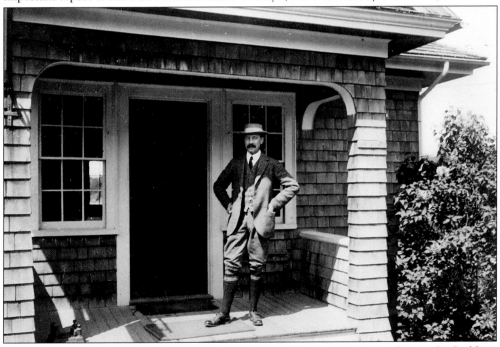

When George Cooksey fell ill, his cousin-in-law and business partner, George L. Stebbins (above), took over managing the Cooksey Realty Company. He dedicated four decades making Seal Harbor a better home for both the cottagers and natives. As a bridge between the two communities, Stebbins not only managed the realty company but also was instrumental in establishing the water company and in developing a public land trust and a neighborhood hall—always with an eye for both promoting and protecting Seal Harbor. (The Dunham family collection.)

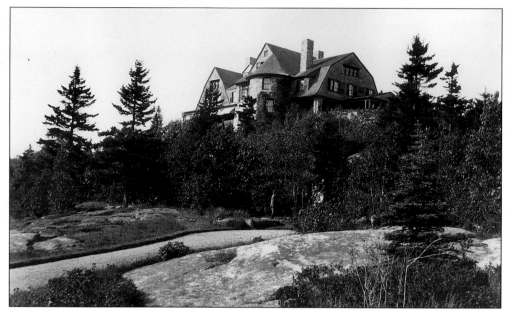

During her first visit to Seal Harbor in 1890, Mary Dows became captivated by its beauty. Four years after her marriage in 1893 to New York physician Edward K. Dunham, the couple built "Keewaydin," an imposing Shingle-style cottage located on a commanding site above the steamboat landing. Designed in 1896 by Isaac H. Green Jr., "Keewaydin" was constructed in 1897 at a cost of $15,000. (The Dunham family collection.)

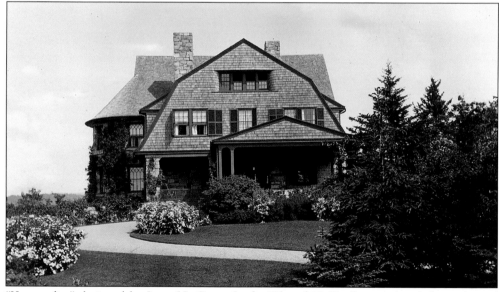

"Keewaydin," designed by Isaac H. Green Jr. for Edward K. Dunham, echoed the scale and complexity of the architect's "Glengariff," done for George Cooksey. Both houses shared broad gambrel roofs sheathed in shingles and featured a rounded stone tower. "Keewaydin" measured 80 feet long and 40 feet wide, with a 50-foot service wing. The stone tower on the ocean side stood 35 feet high. All such cottages featured granite fireplaces and picture windows in social rooms with the inevitable jigsaw puzzle on a nearby table to while away the foggy days. (The Dunham family collection.)

36

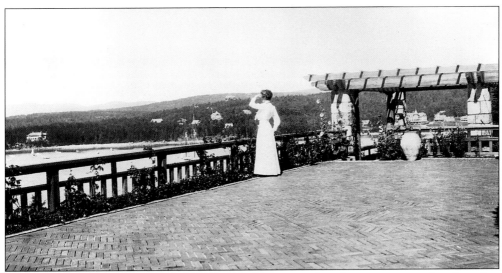

Elegantly dressed in summer white, Mary Dunham watches for incoming yachts from her new brick terrace. When the Dunhams acquired the site for "Keewaydin" in 1896 from their brother-in-law George Cooksey, the *Bar Harbor Record* described the location as "the highest elevation near the water and gives a superb view of both the mountains and the sea." In order to better enjoy this vista, the Dunhams commissioned architect Duncan Candler to add this brick terrace to the harbor side of Keewaydin in 1910. Candler's terrace designs for George Stebbins's "Wabenaki" and Mrs. Marcus Hanna's "Eastpoint" had impressed the Dunhams. (The Dunham family collection.)

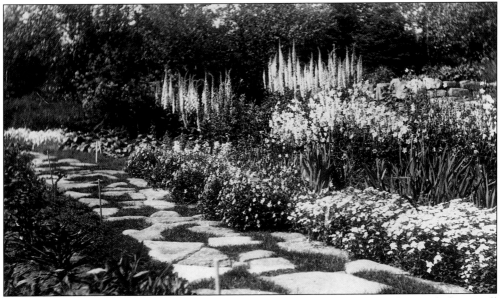

Landscape gardener and Bar Harbor summer resident Beatrix Farrand designed this small garden for "Keewaydin" in 1898, seven short years after she had begun designing at the age of 18. The Dunham garden was among her earliest commissions. It consisted of a weathered fieldstone path with irregular grass panels, flanked by herbaceous borders. The rock wall served as a backdrop for the border, while ascending layers of greenery enclosed the space. (The Dunham family collection.)

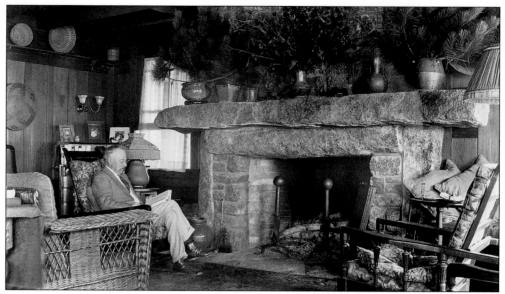

An air of studied informality pervaded Seal Harbor cottage interiors, as in the living room at "Keewaydin." Seated reading by the fireplace is owner Edward Dunham, a distinguished New York physician, pathology professor, and scientific researcher. In his design for the cottage, architect Isaac H. Green Jr. called for a 24-by-28-foot room featuring a large rough stone fireplace, tongue-and-groove cypress walls, and an open beamed ceiling. (The Dunham family collection.)

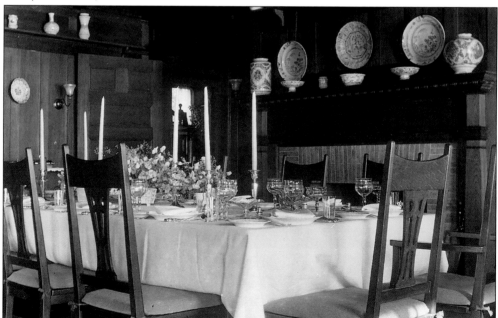

Summer cottage life at Seal Harbor was an intricate blend of formality and informality. These qualities are underscored in this photograph of the dining room at "Keewaydin." Mary Dunham's well-appointed table setting of linen, china, crystal, and silver, along with the rich display of oriental porcelain, contrast with the simplicity of cypress walls and the open beamed ceiling. (The Dunham family collection.)

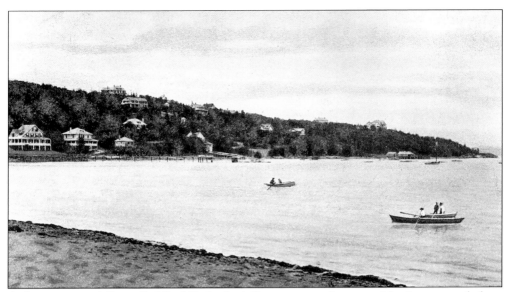

As boaters peacefully sculled Seal Harbor's chilly waters, workers were blasting out roads from the ridge's solid granite for new cottages. Though the architecture and size of these cottages varied, most of them had in common the skill of resident tradesmen: Alanson Clement for roads; Candage and Sons, masons; the Jordans and Blaisdells for plumbing; and the Smallidge brothers for their carpentry. (Maine Historic Preservation Commission.)

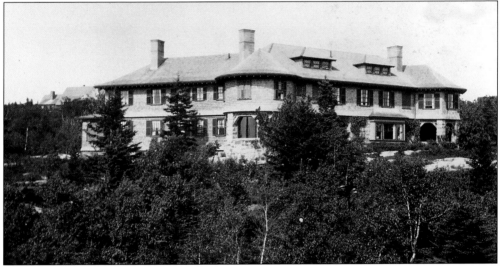

Known as "Eastholm," this Shingle-style cottage was built in 1901–1902 for banker Richard March Hoe and his wife, Annie Dows Hoe. The cottage was based on designs by John M. Carrere and Thomas Hastings, the distinguished New York architectural firm that had planned the Hoes' New York City residence in 1893. The Hoes were an unassuming couple, devoted to community organizations that benefited all Seal Harbor residents, such as the library, the Neighborhood Hall, and the Red Cross. Concerned for the preservation of the village and its surrounding forests, they helped organize the Village Improvement Society, for which Hoe served as president. They also made one of the first gifts of land to the Trustees of Public Reservation, a gift that later formed the nucleus of Acadia National Park. (The Dunham family collection.)

Between 1901 and 1932, the eminent New York architect Grosvenor Atterbury designed four buildings in Seal Harbor. In 1901, Atterbury designed summer cottages for fellow New Yorkers Christian A. Herter and Edward C. Bodman. These were followed within a year by the Congregational church. Nearly three decades later, John D. Rockefeller Jr. asked Atterbury to design at Jordan Pond the French Provincial–style gate lodge, now part of Acadia National Park's carriage road system. Built in 1931–1932, this impressive structure is complemented by Atterbury's Brown Mountain Gate Lodge of the same date in Northeast Harbor. (Maine Historic Preservation Commission.)

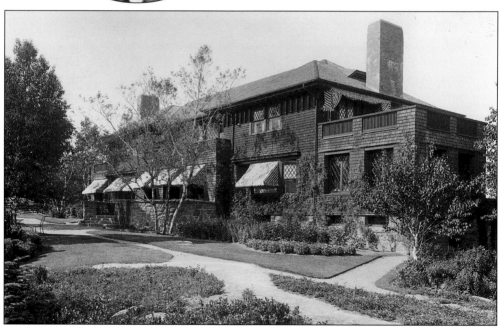

The first of Grosvenor Atterbury's Seal Harbor commissions was "Miradero," a distinctive Arts and Crafts–style cottage built in 1901 for Dr. Christian A. Herter. Named for his father, a New York interior decorator, Herter distinguished himself as a physician, medical professor, and scientific researcher, specializing in diseases of the nervous system. He was among the first to merge scientific investigation with medical science, and he advocated that medical schools and hospitals establish research laboratories. His nephew Christian Herter served as secretary of state under Pres. Dwight D. Eisenhower. (Maine Historic Preservation Commission.)

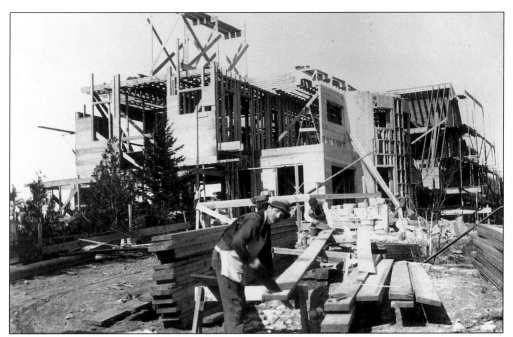

Two carpenters saw a board to size, as "Felsmere" takes form behind them. These workmen were part of a crew of Asa Hodgkins and Sons of Bar Harbor, the contracting firm that transformed Grosvenor Atterbury's blueprints into Edward Cushman Bodman's grand Shingle-style cottage between the summer of 1901 and the spring of 1902. Built at a cost of $25,000, "Felsmere" ranked as one of Seal Harbor's largest early-20th-century summer homes, measuring 111 feet in length and 38 feet in width. (Dr. Henry D. Stebbins)

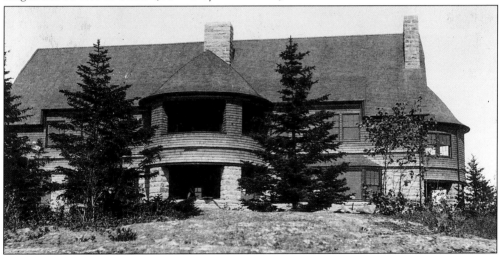

Grosvenor Atterbury's design for "Felsmere" incorporated Shingle-style features such as a rough stone first story which "grows" from the site, frame construction sheathed in shingles, bold rounded porches, and a sweeping roofline. The owner of "Felsmere," Edward C. Bodman, was a partner in the New York grain brokerage firm Milmine, Bodman, and Company. The grounds of the cottage were laid out by landscape architect Beatrix Farrand, reflecting the horticultural expertise of Bodman's wife, Ida Berdan Bodman, an authority on gardening who wrote papers on its history and science for the Garden Club of America. (Dr. Henry D. Stebbins.)

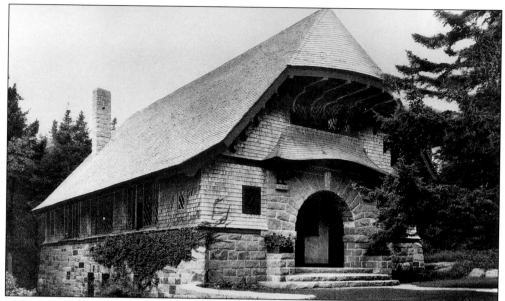

Many of Maine's coastal summer colonies built picturesque chapels, and Seal Harbor was no exception, providing houses of worship for Episcopalians, Congregationalists, and Catholics. Some 15 years after William R. Emerson designed St. Jude's Episcopal Church, Grosvenor Atterbury planned Seal Harbor's Congregational church, a striking blend of Shingle-style and English elements. Erected in 1902, the building was constructed by Charles A. Candage, a local contractor noted for his fine stonework. In 1909, the *Craftsman* magazine praised the church's design, remarking upon its "perfect combination of shingles and stone" as well as the wide overhang of its roof, giving "a vivid impression of the protecting character of the edifice." (Maine Historic Preservation Commission.)

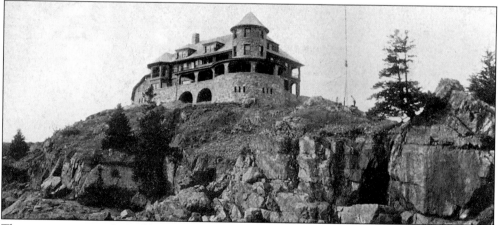

The construction of "Wild Cliff" in 1901–1902 foreshadowed the coming of grander, more expensive cottages to Seal Harbor. Dramatically sited on Pierce Head, this $45,000 stone-and-shingle summer home was designed by the local architect-builder Charles A. Candage for Rev. Alexander Mackay-Smith, an Episcopal clergyman. A native of New Haven, Connecticut, Mackay-Smith was serving as the rector of the historic St. John's Church in Washington, D.C., when construction began on his cottage. In May 1902, he was called to be bishop coadjutor of the Episcopal Diocese of Pennsylvania, a post he held until his death in 1911. (Maine Historic Preservation Commission.)

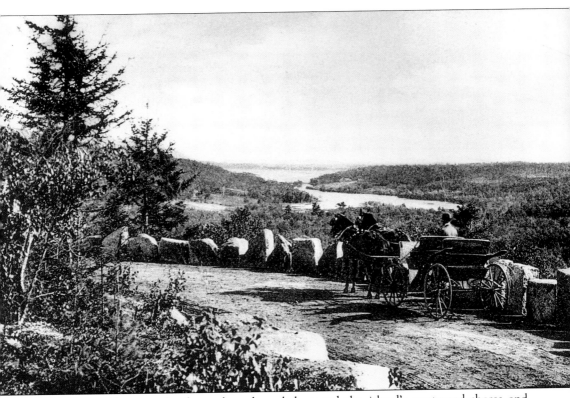

By 1900, a wide network of gravel roads curled around the island's contoured shores and mountains, encouraging visitors on foot, in buckboards, or on bicycles to admire the ocean thundering against rocky ledges or glimpse the distant offshore islands. The buckboard, so named for its springy ride, remained the staple vehicle, but bicycling had become a popular pastime, leading road builders to extol their easy grades. As the horseless carriage made its appearance, summer residents were quick to bar the noisy vehicle from their roads by enacting a law in 1903. The law gave each town on Mount Desert Island the right to exclude automobiles. Each resort town did so. Some 10 years later, voters in Bar Harbor and Southwest Harbor rescinded the ban in their communities. The town of Mount Desert, encompassing Seal Harbor and Northeast Harbor, repeatedly voted against permitting automobiles. Then in 1915, the Maine legislature, heeding cries from islanders who saw the motorcar as a necessity, the key to the island's continued prosperity, overturned the law. (Maine Historic Preservation Commission.)

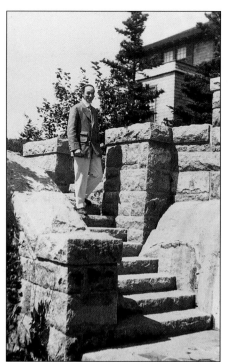

Duncan Candler, the most active of the early-20th-century New York architects to work in Seal Harbor, descends the stone steps of "East Point," the cottage he designed for Charlotte Rhodes Hanna in 1909. A graduate of Columbia University and the Ecole des Beaux-Arts, Marcus Candler was connected to Seal Harbor through his sister, Mrs. George Stebbins, the wife of the town's leading real estate agent. In 1907, George Stebbins gave the architect the first commission of several for summer cottages he designed in the community. Candler later had John D. Rockefeller Jr. and Edsel Ford among his clients; in addition, he provided plans for the Seal Harbor Yacht Club, the first Neighborhood House, and the Seal Harbor Club. (The Dunham family collection.)

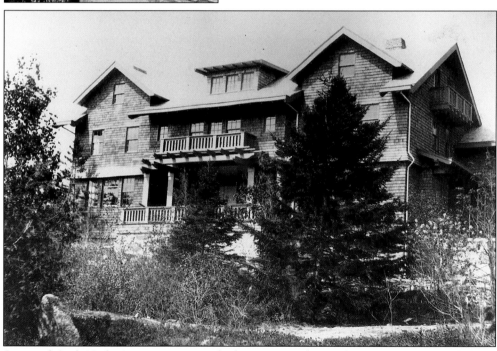

Some of Seal Harbor's cottages were built as seasonal rental properties. One of them, "Wabenaki," was constructed by the Cooksey Realty Company in 1906–1907 from plans by Duncan Candler. The local firm Byron W. Candage and Sons was the contractor. Designed in the Arts and Crafts style, "Wabenaki" featured a broad terrace with the wooden pergola that would become the hallmark of Candler's Seal Harbor cottages. (Dr. Henry D. Stebbins.)

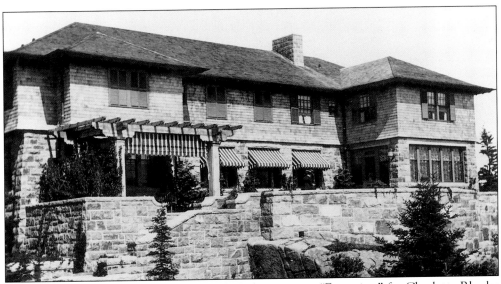

Duncan Candler designed his second Seal Harbor cottage, "Eastpoint," for Charlotte Rhodes Hanna, the widow of Ohio Sen. Marcus A. Hanna. The Hanna cottage, constructed in 1909, was poised on the cliffs east of Cooksey Point. The house was skillfully linked to its rocky site by a rough stone terrace and first story. The second story was sheathed in shingles and capped by a low hipped roof. "Eastpoint" represented the later Shingle style at its best, with an Arts and Crafts influence reflected in the wooden pergola on the terrace. (Maine Historic Preservation Commission.)

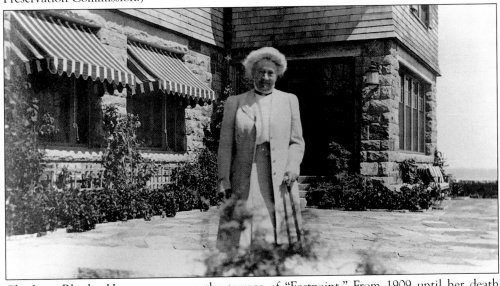

Charlotte Rhodes Hanna pauses on the terrace of "Eastpoint." From 1909 until her death in 1921, Charlotte Hanna, a warm and congenial person, was an active member of the Seal Harbor summer community, arranging the entertainment for Pres. William Howard Taft's 1910 visit and raising the funds for building Seal Harbor's Catholic chapel. Her late husband, Marcus A. Hanna of Cleveland, Ohio, made his fortune in coal and iron and achieved his national reputation as the manager of William McKinley's successful effort to secure the Republican presidential nomination and win the campaign in 1896. Hanna succeeded McKinley as an Ohio senator, serving until his death in 1904. (The Dunham family collection.)

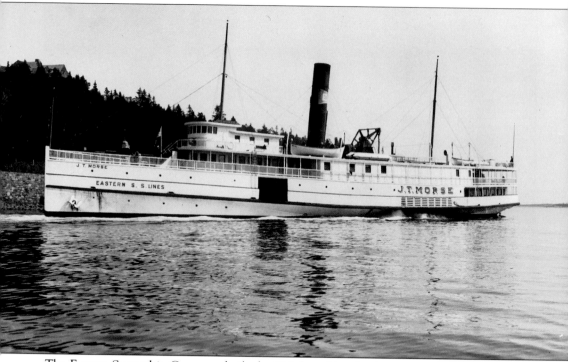

The Eastern Steamship Company built the 214-foot side-wheeler steamer *J.T. Morse* in 1903 to replace the smaller *Mount Desert*. Since the company retained the crew on the larger vessel, visitors could rely on seeing Capt. Frank Winterbotham at the helm and getting a bright Irish smile and personal greeting from Maggie Higgins, the sole stewardess on board, whom many considered the true commander of the ship. For many families, the summer holiday commenced and ended with a ride on the *Morse*, as she forged through the waters between Rockland and Mount Desert. The steamer's daily whistle became part of summer memories. Cargo varied with the season and year but, over time, included rabbits, horses, carriages, small sailboats, artwork, and finally, after 1915, automobiles. With the advent of the car to the island, steamer travel began to wane and, by the 1930s, the *Morse* was the only steamer left plying the Maine waters. Following 30 years of service, the last 10 under the guidance of Captain Thompson, the ship was sold to a New York company in 1933. (The Dunham family collection.)

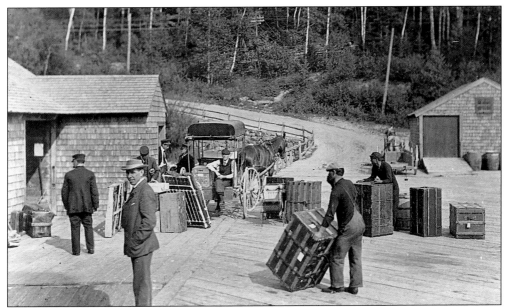

Before automobiles and trucks were common, steamers transported people and cargo to the island. At the Seal Harbor wharf c. 1905, the passengers have departed for their cottages to await in comfort the delivery of trunks, beds, prams, and artwork. The journey, often having begun the prior day, left visitors travel weary but eager to start their vacation. (The Dana family collection.)

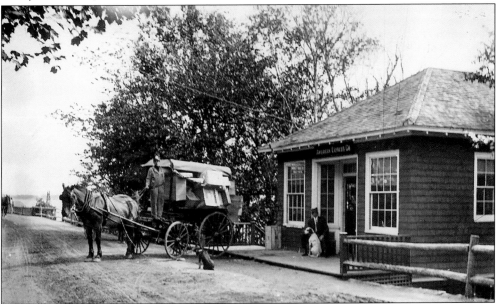

When Charles Clement became a clerk for the American Express Freight Company, he built this small office along the street between the wharf and the village. Here, parcels could be collected or mailed. Edwin Jordan ran a small business at one time, using his horse-drawn cart or sled to deliver goods to the homes for a small fee. Below this c. 1900s building stood the Seal Harbor Fish Company, also operated by Clement and his two sons Irving O. and Arthur M. Clement. (The Liscomb family collection.)

Many Maine communities in the late 19th century followed the national trend of establishing local libraries. In 1898, the year-round and summer residents joined together to raise the $1,000 needed to build the Seal Harbor Library. Native Charles H. Clement and New Yorker George Cooksey donated a prominent site tucked between the Sea Cliff drive and the road leading to the steamboat wharf. Designed by New York architect William T. Partridge, the Seal Harbor Library was constructed between May and July 1899, with local workmen donating their services. In the century since this New England Cape–style structure opened on July 28, 1899, the library has been, in the words of a period newspaper, "a decided addition to this place." (The Dunham family collection.)

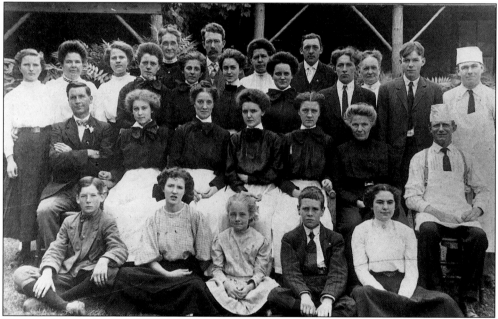

The steady influx of patrons to feast on chicken dinners and popovers at the Jordan Pond House meant summer employment for local men and women. In front of the owners, Nellie and Thomas McIntire (back center), the staff pauses from cooking, waitressing, management, and hostessing duties for a portrait c. 1910. (Great Harbor Collection.)

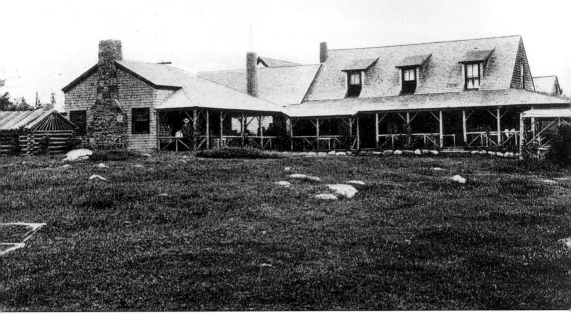

It is no wonder that the Jordan Pond House became as widely known for its hospitality as for its good food and tranquil surroundings. Owners Nellie and Thomas McIntire expanded the farmhouse several times to accommodate the growing patronage. By 1910, the guests could dine in any of six private dining rooms, freshen up with a shower bath before their meal, and enjoy midday chicken dinners or afternoon tea on the extensive veranda skirting the building. Lobster, once considered common food, was added to the menu. Suppers had become so popular that, by the early 1900s, the McIntires had the Jordan Pond House wired for electricity. Often the place was a stop on an all-day excursion. Tables in cozy nooks and comfortable rockers would tempt weary hikers to stop and feast on popovers, if their blueberry picking activity had left any appetite. Tea on the veranda or lawn afforded the visitors a panoramic view of Pemetic and Jordan (Penobscot) Mountains, and the Bubbles reflected in the glassy pond. (Maine Historic Preservation Commission.)

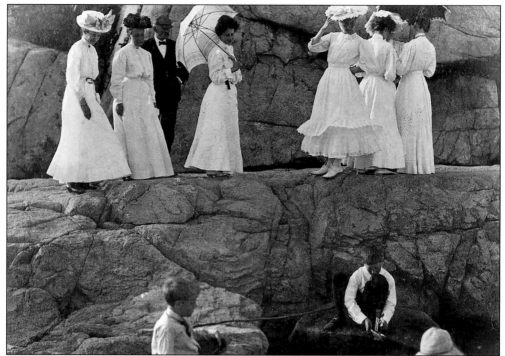

Mount Desert's bold, rocky cliffs and ledges attracted the summer visitors in swarms. Despite the billowing gowns and pinching pointed shoes of the times, women ventured up mountains and out to remote destinations, such as Bakers Island. At this outing *c.* 1904, women promenade along the rocks, shaded by broad-brimmed hats and parasols, while their young sons in starched shirts and ties play with their boats in the tidal pool. (The Dana family collection.)

After climbing up Sargent Mountain, these women are resting before their descent. In 1909, shortly after this photograph was taken, Boston lawyer Waldron Bates, who dedicated time and energy to creating, maintaining, and mapping many of the trails, died at the age of 53. In his memory, the Bar Harbor Village Improvement Association completed the planned improvements to Chasm Path and renamed it the Waldron Bates Memorial Path. (The Dana family collection.)

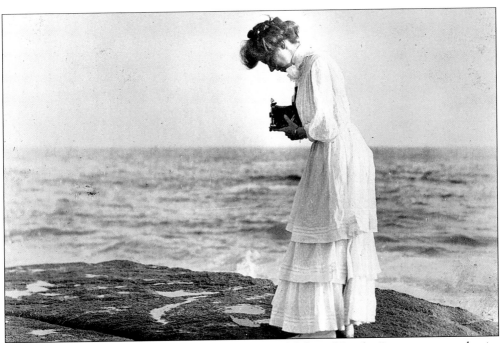

The popularity of photography and the increased availability of "pocket" cameras created quite a few "snapshooters" in the Seal Harbor community, including Caroline Bristol Dana, who captured her fellow photographer on film. Some rusticators even used a basement room in the Seaside Inn for a darkroom. (The Dana family collection.)

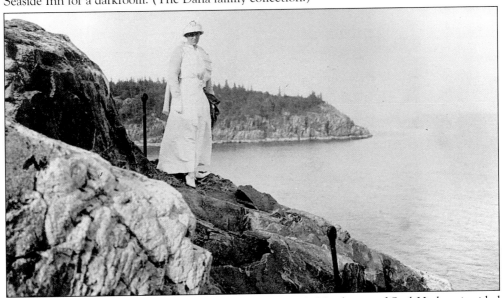

Alice Dows hiking along the new Shore Path at Hunter's Head, east of Seal Harbor, is aided by a series of iron rods. Creating sections of this path challenged the engineering ingenuity of Seal Harbor's Village Improvement Society. Parts of the path were blasted out of solid rock, while other sections needed bridges, held by iron braces, for easy passage. When these were completed, explorers could revel in unsurpassed views of Sutton and the Cranberry Islands off Mount Desert Island's southern shore. (The Dunham family collection.)

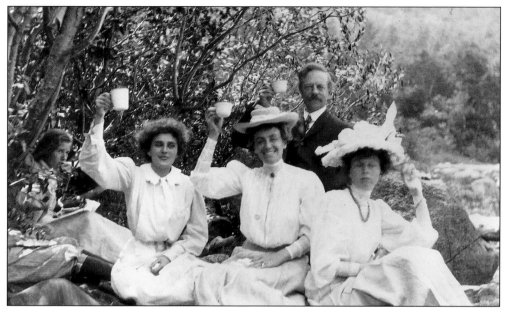

Dr. and Mrs. Edward Dunham (center) join their friend Aileen Tone and cousin Violet Westcott to toast one of their favorite Victorian era pastimes: a picnic at Bubble Pond. As their daughter Theodora Dunham recalled, all the cousins and their friends would gather there annually for her birthday: "Some of us rode or went in the donkey cart and the rest in six-seater buckboards with the ice cream freezer, food, and birthday cake strapped to the rear. The morning was spent swimming or riding astride logs floating in the water. Then came the feast ending with ice cream and birthday cake decorated with candy stick candles." (The Dunham family collection.)

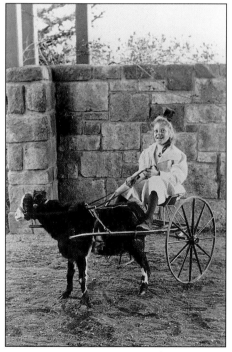

For young children such as Theodora Dunham, rides in wooden goat carts and dogcarts were part of their regular afternoon activities. At times, the goat's stubbornness could match that of any child. One day Theodora drove her cart all the way to Asticou in Northeast Harbor and, on her return trip, the tired goat lay down on the road opposite the Glencove Hotel. Theodora's frustration with the goat's lack of cooperation was only exacerbated by humiliation, when a hotel guest strolled over and lifted the goat to its feet. (The Dunham family collection.)

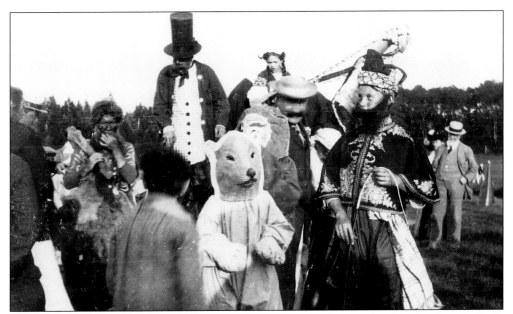

In pre–World War I days, Seal Harbor annually sponsored a County Fair. Held at Bracy's Field, named for Squire John Bracy, one of the community's original settlers, the fair raised money for local charities. On this particular occasion, a lovable bear pauses to consider his options. Surrounded by a Cossack on the right, a towering man on stilts, and a savage on the left, what could he do? Possibly he could escape to one of the goat-cart races or footraces in hopes of winning some popcorn or peanuts. (Dr. Henry D. Stebbins)

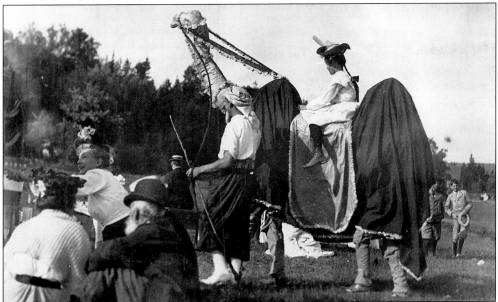

Women laced into wasp-waist dresses and men decked in ice-cream pants, dark coats, and stylish boaters stroll through the fair, admiring the costumed guests. Here, a turbaned escort parades his two-humped camel around in search of the real desert. At the fair's conclusion, these elaborate garments were packed in trunks and stored in capacious cottage attics, ready for the next round of fancy dress affairs. (Dr. Henry D. Stebbins.)

Recognizing that the recent inventions of the automobile and the portable power saw could threaten the thickly wooded forests and solitude of Mount Desert Island, Charles Eliot (above at Jordan Pond), the president of Harvard, advocated that the future of the island as a summer resort rested on the residents' shoulders and that "whole island ought to be treated . . . as if it were a public park." As a first step, Seal Harbor's residents incorporated their Village Improvement Society to maintain common community areas, including roads and paths. To address the threat to the entire island from developers, members of the society, including George Stebbins and Edward Dane, joined with Eliot of Northeast Harbor, George Dorr of Bar Harbor, and others to incorporate the Hancock County Trustees of Public Reservations. Approved by the Maine legislature in 1903, the trustees sought to conserve and maintain the unique natural beauties of Mount Desert by "acquiring, owning, and holding lands and other property in Hancock County for free public use." The first steps toward creating Eliot's "park" had begun. (Maine Historic Preservation Commission.)

Houses draped with bunting and yachts dressed with flags marked Seal Harbor's centennial celebration of the Clements' first home in 1809. The first three speakers, Edward Dunham, cottager and theologian William A. Brown, and Charles Clement recalled the village's early beginnings and proudly noted that the community's strength derived from the common spirit found between the permanent and the summer residents working together for the entire community's benefit. Crawford Toy, a Harvard professor, closed the ceremony with his commemorative poem, after which fireworks lit the sky. (The Dunham family collection.)

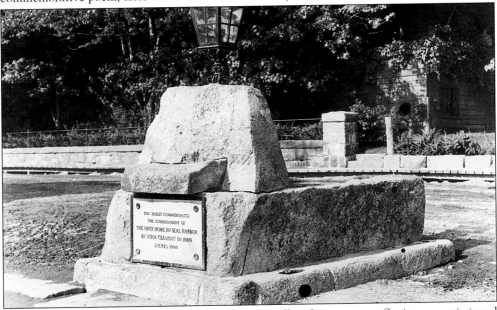

In the pre-automotive year of 1909, the Seal Harbor Village Improvement Society commissioned local mason Sam Candage to erect a rustic stone watering trough to recognize the community's centennial year. On this monument a plaque reads, "This tablet commemorates the establishment of the first home in Seal Harbor by John Clement in 1809." In 1910, the trough was embellished with an ornamental lantern and a bronze waterspout in the form of a seal's head. (Lyda Carter Noyes.)

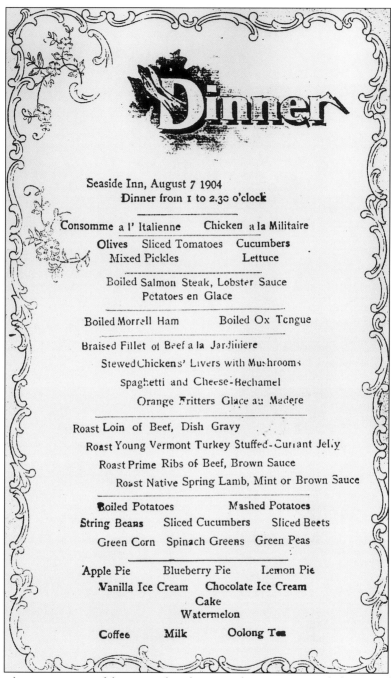

Dinner

Seaside Inn, August 7 1904
Dinner from 1 to 2.30 o'clock

Consomme a l' Italienne Chicken a la Militaire

Olives Sliced Tomatoes Cucumbers
Mixed Pickles Lettuce

Boiled Salmon Steak, Lobster Sauce
Potatoes en Glace

Boiled Morrell Ham Boiled Ox Tongue

Braised Fillet of Beef a la Jardiniere

Stewed Chickens' Livers with Mushrooms

Spaghetti and Cheese-Bechamel

Orange Fritters Glace au Madere

Roast Loin of Beef, Dish Gravy
Roast Young Vermont Turkey Stuffed-Currant Jelly
Roast Prime Ribs of Beef, Brown Sauce
Roast Native Spring Lamb, Mint or Brown Sauce

Boiled Potatoes Mashed Potatoes
String Beans Sliced Cucumbers Sliced Beets
Green Corn Spinach Greens Green Peas

Apple Pie Blueberry Pie Lemon Pie
Vanilla Ice Cream Chocolate Ice Cream
Cake
Watermelon

Coffee Milk Oolong Tea

One of the keys to a successful summer hotel was its dining room, and the Seaside Inn was noted for its meals, as is reflected in this 1904 dinner menu. Proprietors Amos Clement and James Clement Jr. assured prospective guests in a period advertising brochure that "our table will be supplied with all kinds of fresh fish from the sea each day, vegetables from our own garden; meats, etc. . . . from Boston markets, and, with a closer attention to our cuisine, we are confident that we shall please all. Price of board, $8 to $12 per week, according to location of room." (The James D. Clement family.)

56

Three

A Bustling Resort: 1911–1920

At this Fourth of July celebration on Seal Harbor's main commercial corridor, an optimistic outlook for the village's future prevailed. Just as these young boys vied for first place in the potato race, local developers James Clement and George Stebbins were competing with neighboring resorts to draw wealthy "summercators" to Seal Harbor. Their success in convincing John D. Rockefeller Jr. and Ernest B. Dane to build estates on their hills added to the existing building boom. Though a few new educators built cottages, increasing numbers of businessmen made Seal Harbor their summer home. The relaxed social style began giving way to more formal gatherings and social organizations for both summer and permanent residents. Sojourners gathered in their cottages, congregated at the Cliffs Tennis Courts on Ox Hill, or met for tea. Year-round residents used the new Neighborhood Hall for plays, basketball games, and lodge meetings. Eventually, the war relief efforts brought the entire community together to supply needed materials to French hospitals. (The Liscomb family collection.)

Between 1908 and 1920, Seal Harbor's merchant district expanded. While automobiles were still barred from Seal Harbor, local businesses thrived. Macomber's store and post office on the right and Whitmore's store closer to the harbor offered a general selection of dry goods; Mr. Billing's market, between the two, specialized in produce and meats for the more selective clients. Those in need of a carriage could find one for hire at Lynam and Campbell's stable (right), topped with a distinctive cupola. (Maine Historic Preservation Commission.)

This southern section of the commercial area witnessed the most dramatic change in one decade, completing the last stage of George Cooksey's original village plan. Closing their doors after 30 years of business, the Glencove Hotel proprietors sold their property to John D. Rockefeller Jr., who donated the land for a village park. In 1919, the Glencove was torn down and the grouping of stores seen on the right was moved north to make room for a sweeping village green. (The Liscomb family collection.)

58

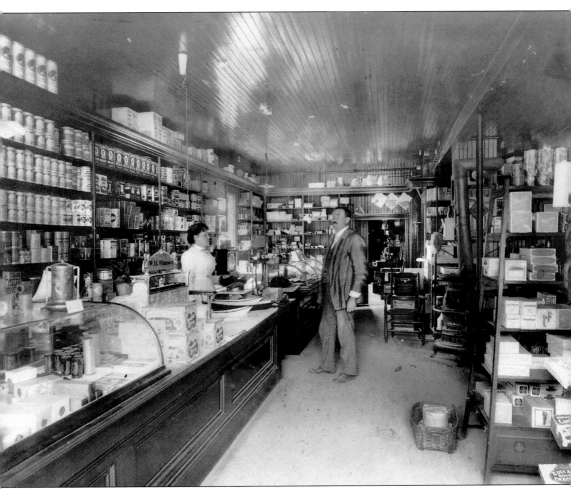

As Emma Whitmore and her brother Joseph Whitmore look over their store, they could probably recall little change since the family purchased J. Ames's general store in 1890. Warren and Joseph Whitmore, lobstermen, had visited the harbor as early as 1888. Seeing the resort's growth prospects, they left fishing for a more secure occupation. The two-story, 36-by-26-foot general store offered ample room for goods and comfortable quarters for the men upstairs. It was not until after 1900 that Emma Whitmore joined her brothers. No matter how life in Seal Harbor changed, the residents, thereafter, could count on her being in the store, dressed in Victorian garb and displaying peppermints in her case. Years later, as residents did more of their shopping in neighboring towns, the store shelves became bare, but Emma Whitmore still kept her door open and a supply of candy ready for visiting children. (Rockefeller Archive Center.)

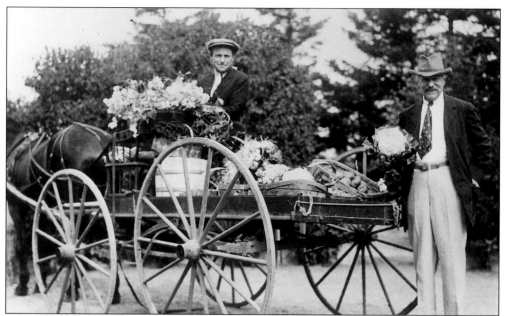

With his cart loaded with freshly picked flowers and homegrown vegetables, this local grower would stop at each cottage to show his fine selection to the cook. In this instance, the deliveryman met an affable Dr. Edward Dunham, who selected a handsome cauliflower for his meal. Many Otter Creek farmers sold their goods directly to the cottagers in this manner or tended private garden plots for the cottage owners whose granite bound properties were unsuitable for vegetable gardens. (The Dunham family collection.)

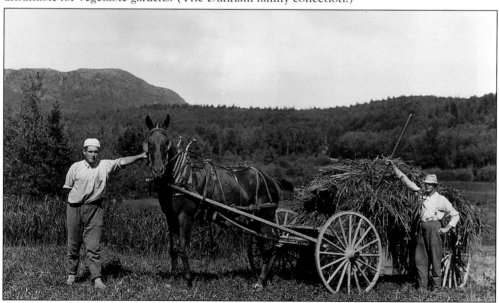

The island's attractions to settlers in the early days included plentiful marshes for growing cattle feed and enough land for subsistence farming. Around Seal Harbor, farming was concentrated in five areas: Long Pond; behind the Seaside Inn; Wildwood Farms, which later became part of the national park; Otter Creek, famous for its produce and flower nurseries; and land near Sand Beach, where these worker are harvesting marsh grass. (The Dunham family collection.)

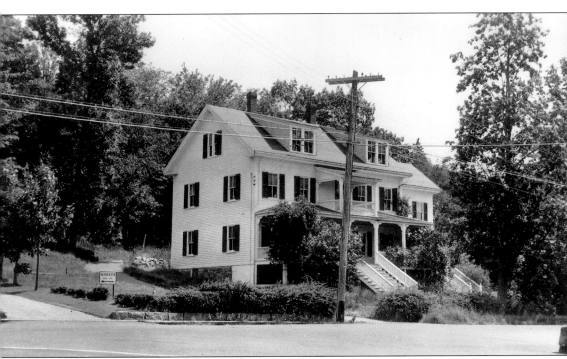

The homes of Seal Harbor's permanent residents varied as much in style as in function. Thomas McIntire lived in this home overlooking the harbor only in the off-season, renting it to visitors each summer while he and his family lived at the Jordan Pond House. Henry Smith of North Haven originally built the house, "Birch Grove" in 1888, for summer use only and sold it to McIntire in 1907. Similarly, the Robert Campbells and Clements, year-round residents who had built cottages nestled around the harbor, vacated either all or portions of their homes each summer to renters. Some merchants lived on the second floor of their stores; others built modest bungalows along the Jordan Pond Road. Some native craftsmen took pride in their unique designs. Mason Byron Candage's cottage, built between 1888 and 1895, boasted nine fireplaces, no two alike. One combined rough stone with an alcove of beveled glass; cut stone adorned another; Corteraig brick with rough edges outlined a third; and Perth Amboy, yet another. The remaining fireplaces were built with various types of brick. The Candage family's skill in masonry shone throughout the 16-room house. (Rockefeller Archive Center.)

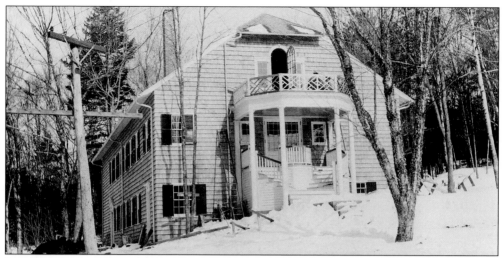

Recalling the success in building the Seal Harbor Library in 1899, year-round and summer residents planned in 1913 a community hall in which to hold suppers and entertainment. The Neighborhood House Corporation sold $10,000 in stock to raise the funds to purchase the site at Jordan Pond and Old County Roads and to construct a 40-by-70-foot two-story Colonial Revival building, designed by Duncan Candler. Commenting that the Neighborhood House commanded "a very fine view down the Main Street," the *Bar Harbor Record* of October 15, 1913, described a sizable banquet hall in the basement, equipped with a kitchen, while the first floor was devoted to a large assembly hall, complete with a stage and a gallery. When the Neighborhood House burned in 1919, it was quickly replaced the same year. (The Dunham family collection.)

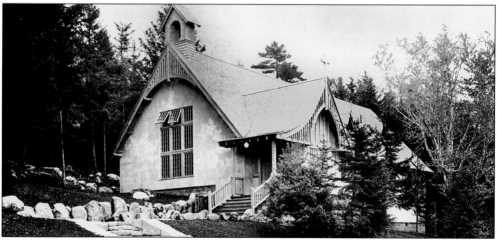

At the start of the 20th century, many of the cottage employees in Maine summer colonies were Roman Catholics, and several communities built seasonal chapels to provide for the religious needs of their staff members. In Seal Harbor, Charlotte Rhodes Hanna led the effort to construct a Catholic church. A site on the east side of the Jordan Pond Road, north of the business corridor, was secured in 1911, and a 30-by-65-foot chapel in the English half-timbered style was constructed the next year. W.S. Smallidge provided the carpentry work, and B.W. Candage and Son laid the masonry, including the handsome stone retaining wall and entrance steps. As the building neared completion, Father O'Brien of Bar Harbor opened the chapel with its first service on Sunday, July 14, 1912. (Maine Historic Preservation Commission.)

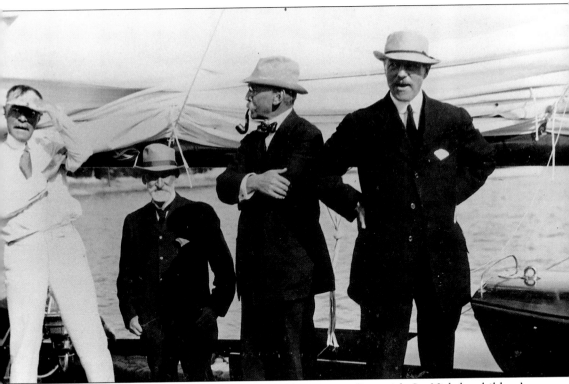

Enjoying a sail are, from left to right, Samuel Chapin, an editor with *St. Nicholas* children's magazine; Crawford Toy, professor of Hebrew at Harvard Divinity School; Richard Hoe, a banker; and Edward Dunham, a pathologist. Each man represented a group of Seal Harbor's summer colony. Toy was drawn to the resort in the 1880s by fellow Harvard theologians Everett, Thayer, and Lyons, who delighted in tracing the origins of the streams. As Bishop Mackay-Smith had found tranquility in Seal Harbor, so too did ministers Henry Van Dyke, William Adams Brown, William Manning, and local Maine pastors John Penman and A.S. Windsor. George Cooksey's salesmanship convinced his brothers-in-law Hoe, Dunham, and Christian Herter, along with their scientific and business colleagues, to join the community. For others, such as Joseph Allen and Walter Shaw, it was not familial or business connections that drew them to the island but the attraction of exploring its diverse natural beauties. (The Dunham family collection.)

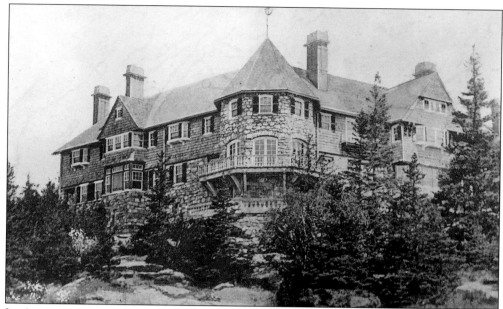

In August 1909, banker Ernest B. Dane of Brookline, Massachusetts, purchased George B. Cooksey's "Glengariff" and 15 acres of land on the east side of the harbor. The following March, he demolished the 19-year-old cottage down to the foundation, and began constructing a massive new "Glengariff," which measured 244 feet long by 40 feet wide. Designed in the Shingle style by F.L. Whitcomb of Boston, the house was completed for the summer of 1911. On October 12, 1910, the *Bar Harbor Record* commented, "There have been two hundred barrels of lime used already and the work doesn't appear to be half done. There are at present at work on the house about 60 men and on the wharf 50 more, making 110 men in all. The payroll of the men now working on this job is $1300 to $1500 a week." (Seal Harbor Library.)

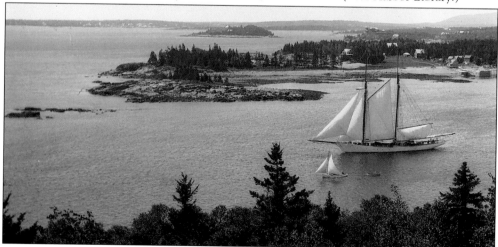

Complementing the size of "Glengariff" was Ernest B. Dane's 135-foot gaff-rigged auxiliary schooner *Cone*, built in 1906 by R. Palmer and Sons of Noank, Connecticut. To accommodate the *Cone* and his 70-foot steam yacht *Needle*, Dane built a substantial private wharf below his cottage. In 1909, he loaned the *Cone* to his cousin, Bar Harbor cottager John Dane, for his honeymoon cruise with Eunice Cooksey, daughter of Glengariff's previous owner. (The Dunham family collection.)

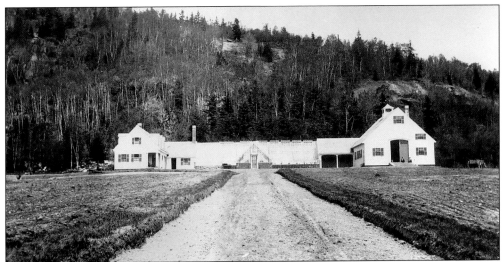

As soon as the new "Glengariff" was completed in 1911, Ernest B. Dane began another major building project: a 100-acre model farm known as "Wildwood." The complex consisted of a farmhouse and stable connected by a 40-foot greenhouse, with an adjacent tennis court. As the *Bar Harbor Record* observed on November 22, 1911, "The location of these buildings is about ideal. Two of the Triads almost overhang them on the north, while the fields and woods slope gently off to the south, allowing a fine view of the islands and ocean." (Maine Historic Preservation Commission.)

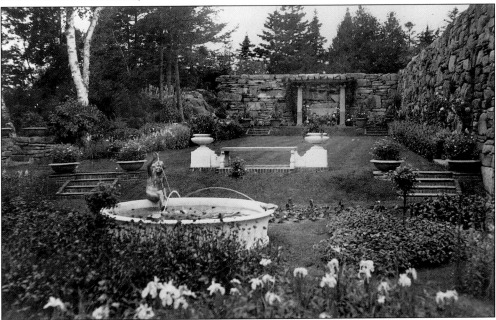

In 1912, Ernest B. Dane hired architect I. Howard Jones to assist him in planning his walled garden at "Glengariff." Laid out on the old road that led to the original house, the garden provided a level, grassy, enclosed space at this otherwise rocky, steep site. Local tradespeople constructed the extensive stonework encircling the garden. Though no longer extant, the walled garden so impressed the Garden Club of America in the 1930s that it highlighted the garden in its guides. (The Liscomb family collection.)

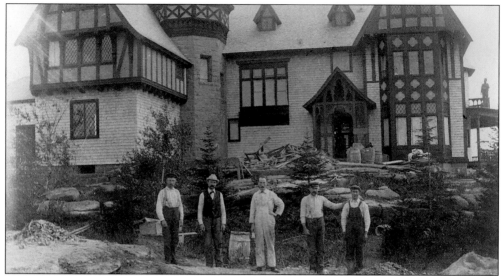

Samuel Fessenden Clarke, who taught biology at Williams College, was another professor attracted to Seal Harbor. In 1897, he commissioned Williams graduate Marcus T. Reynolds, an Albany, New York architect, to design a romantic half-timbered cottage named "the Eyrie," because of its elevated site overlooking the harbor. Here, workmen pose in front of the nearly completed cottage in 1897–1898. Clarke and his family thoroughly enjoyed their Seal Harbor vacations, for he later wrote that the town "was a wonderful spot for a summer home. We must all travel up there again some happy day, delight our eyes again with the happy grouping of mountains and valley, the picturesque rocky shore line with its coves and partly wooded cliffs, old ocean, and the lovely islands." (Rockefeller Archive Center.)

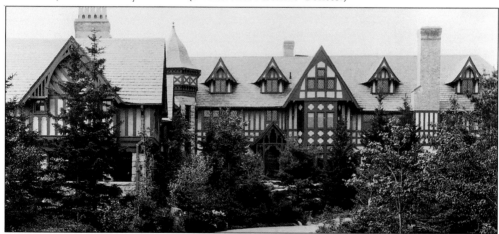

In 1910, John D. Rockefeller Jr. purchased "Eyrie" from Samuel Fessenden Clarke for $26,000. Associated with his father in the Standard Oil Company, Rockefeller had first summered on Mount Desert as a college student in 1893. In 1908, he and his wife, Abby Aldrich Rockefeller, leased the Sears Cottage in Bar Harbor before the August birth of their third child, Nelson Rockefeller. Refreshed by the beauty of the island, the Rockefellers rented houses in Seal Harbor in 1909 and 1910, acquiring the Clarke property that year. In 1915, architect Duncan Candler was hired to plan a major expansion in which the Clarke Cottage became the core of a 100-room half-timbered mansion (above) to accommodate a growing family, along with numerous guests and a full staff. (Maine Historic Preservation Commission.)

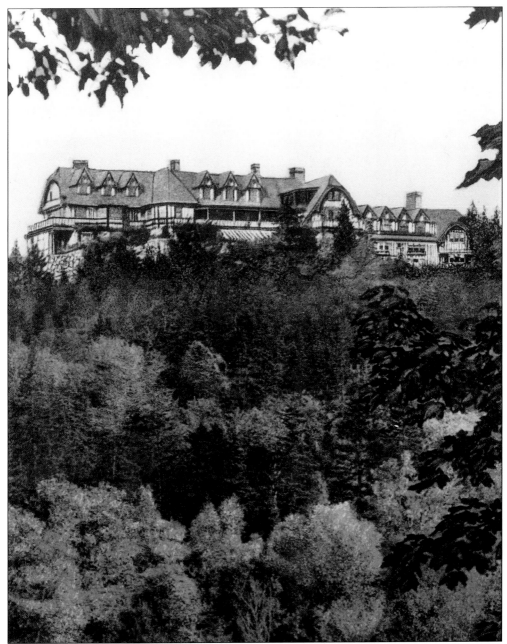

The commanding location and immense size of the Rockefellers' "Eyrie," are captured in this photograph taken from Long Pond in Seal Harbor. Using Duncan Candler's plans, John D. Rockefeller Jr. employed local contractor B.W. Candage and Son to transform Samuel Fessenden Clarke's cottage into a 160-foot-long mansion containing more than 20 fireplaces and bathrooms, as well as two elevators. The contractors laid the foundation in the spring of 1915 and constructed the house between the fall of that year and the following spring. The roof alone required five carloads of slate. Three years after Rockefeller's death in 1960, "Eyrie" was torn down; however, the house continues to be remembered as one of Mount Desert's grandest summer residences. (Maine Historic Preservation Commission.)

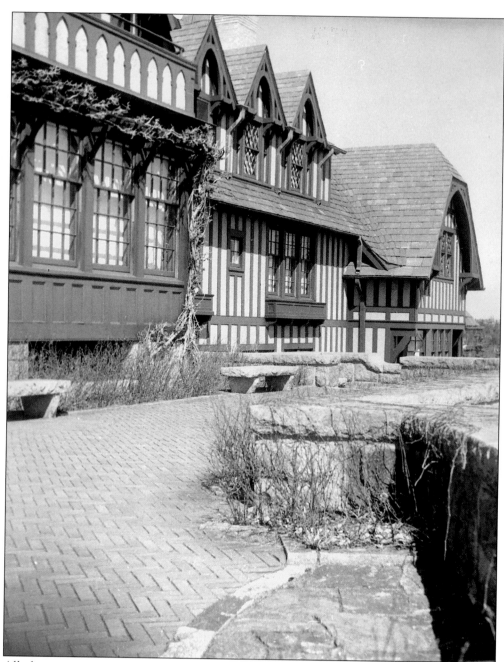

All that remains today of the Rockefellers' cottage is the brick-and-stone terrace in the foreground, which surrounded the picturesque English half-timbered mansion, providing residents and guests with spectacular views as far out to sea as Mount Desert Light. "Eyrie" featured the largest of Duncan Candler's skillfully designed and constructed masonry terraces, which were also found at Seal Harbor cottages such as "Wabenaki," "Eastpoint," "Keewaydin," and "Skylands." (Northeast Harbor Library.)

John D. Rockefeller Jr. and Abby Aldrich Rockefeller stand together on the "Eyrie" terrace. In 1910, the year in which he had purchased his Seal Harbor cottage, Rockefeller decided to shift his attention from business to philanthropy. Among the many beneficiaries of this decision was his newly adopted summer home on Mount Desert, where he later built a carriage road system and played a major role in assembling the land for Acadia National Park. Beginning in 1926, Abby Aldrich Rockefeller worked with her husband and the noted landscape architect Beatrix Farrand to create a garden at "Eyrie," which incorporated both Oriental and Western themes. In the nearly 50 years since her death in 1948, this great private garden has been maintained by family members. (The Liscomb family collection.)

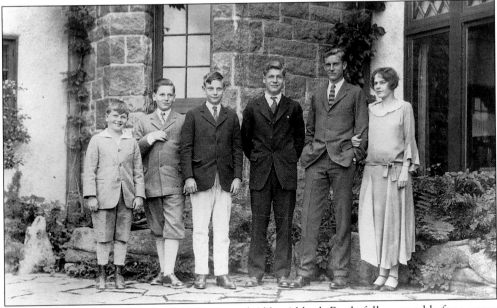

The six children of John D. Rockefeller Jr. and Abby Aldrich Rockefeller assemble for a group photograph on the "Eyrie" terrace in the 1920s. They are, from left to right, David, Winthrop, Laurance, Nelson, John D. III, and Abby Rockefeller. David became a banker and civic leader; Winthrop, governor of Arkansas; Laurance, a venture capitalist and conservationist; Nelson, governor of New York and vice president of the United States; and John D. III and Abby, philanthropists. As adults, both Nelson and David Rockefeller built their own summer homes in Seal Harbor. (The Liscomb family collection.)

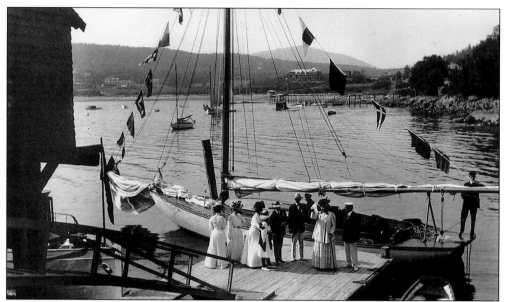

Before the Seal Harbor Yacht Club was built in 1912, yachtsmen used the steamship wharf as a landing. In this 1908 photograph, Charlotte Rhodes Hanna (second from right) is joined by her fellow sailors to christen her sloop *Marcana*, named after her late husband, Ohio Sen. Marcus Hanna. An enthusiastic sailor, she became one of the founders of the yacht club shortly after this photograph was taken. (The Dunham family collection.)

Seeking both greater privacy and social ambiance than was afforded by the steamboat wharf, a few Seal Harbor cottagers with sleek new vessels built a yacht club set upon the harbor's eastern granite ledge. The modest two-story building offered them a place to gather for social teas after sailing. Professional crews could use the fully tooled workshop and sail loft, and a club custodian lived in simple quarters on the second floor. (The Dunham family collection.)

A longtime fixture at the Seal Harbor Yacht Club was Capt. James F. "Fred" Bracy, shown here after the club had been enlarged in the 1920s. Scion of a prominent Mount Desert family, Bracy taught many a summer youth to row a dory, splice a line, and care for sails. As "harbor master" he supervised the myriad boats, both sail and power, moored in the harbor and, with his ready smile, welcomed visiting yachtsmen. His own launch was often rented for summer outings to the offshore islands. A favorite recollection of such an outing was an early summer expedition to stock a cottage icehouse with fish. With Bracy as guide to the best grounds, the haul of cod and haddock caught by dropline was sufficient for the entire season. (The Dunham family collection.)

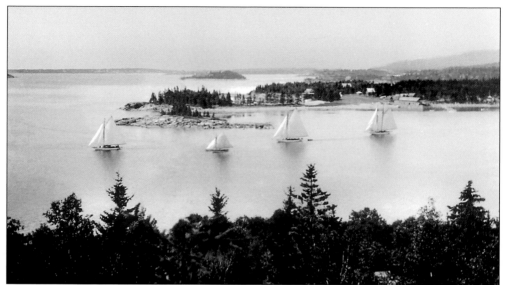

Prevailing summer southerlies and a rather constricted harbor mouth made such parades of yachts a spectacular sight. Here Edward Dunham's *Neith* leads Frank Damrosch's *Polly*, Christian Herter's *Suzetta*, and E.C. Bodman's *Vision* past tiny Thrumcap Island for an afternoon sail in the Eastern Way. (The Dunham family collection.)

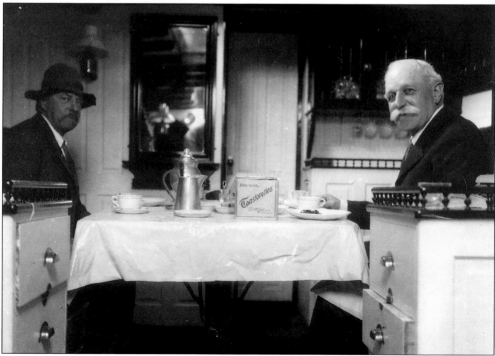

The owners of the 53-foot Herreshoff-designed *Neith*, Edward Dunham and Richard Hoe relax over tea and Educator Tostorollos biscuits in the yacht's well-appointed saloon. Converted from gaff to Marconi rig, *Neith* took its name from the Egyptian goddess of sport. The yacht continued to sail in New England waters 90 years after her launching, and beyond. (The Dunham family collection.)

While the professional captain mans the helm and the crew rests on the foredeck, owner Edward Bodman enjoys the sail in jacket, cap, wing collar, and tie. His son George, in his Yale 1905 sweater, and guest Wood Rutter, with pipe, were ready to lend a hand when sail changes were demanded but were spared the continual maintenance chores. (The Bodman family collection.)

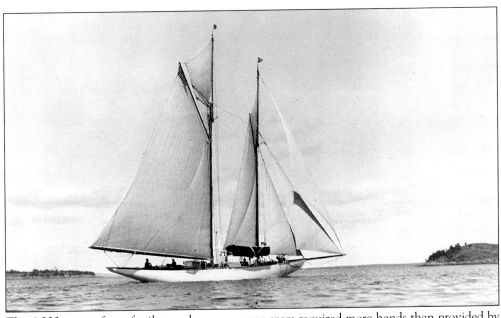

The 6,000 square feet of sail spread over so many spars required more hands than provided by owners and guests. The *Cara II*, a 65-foot topsail schooner briefly owned by Edward C. Bodman in 1908 and 1909, had a professional crew of four: a captain, two Scandinavian seamen, and a cook, all of whom lived aboard. (The Bodman family collection.)

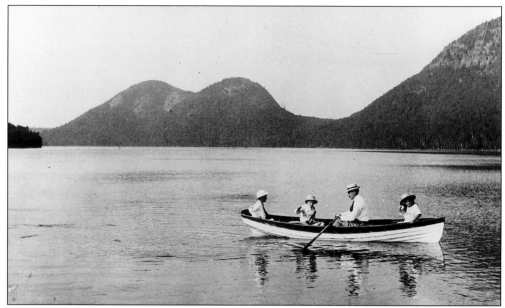

Against the background of the Bubbles, George Stebbins rows his children, from left to right, Ledyard, Henry, and Marcia Stebbins, across Jordan Pond, seeking that ideal picnic spot. Some families preferred far more civilized picnics with stewards setting hot rocks from a blazing fire before each picnicker for the searing of steaks. Others delighted in still greater refinement: tables, linen, china, and crystal. (The Dunham family collection.)

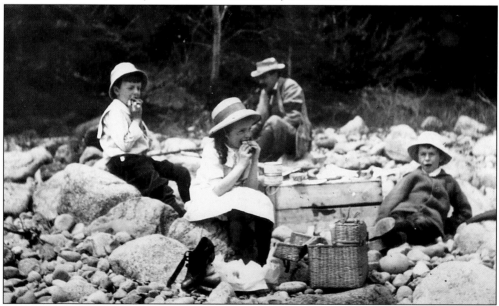

Having found a comfortable rock, the Stebbins family settles down around a wicker basket for a sandwich lunch. Ledyard Stebbins's favorite picnics were those on Bakers or Great Cranberry islands, "where we cooked excellent chops on fires built in the clefts of the seashore rocks. After lively conversation, we returned in the evening . . . singing then popular songs such as 'My Darling Clementine,' and 'The Wreck of Engine 49.'" Dipping fingers in the shimmering phosphorescence during the return boat trip was a special delight. (The Dunham family collection.)

Companions Violet Westcott (left) and Aileen Tone dangle their feet in Bubble Pond's cool water while the children have a refreshing swim. Maine's chilly ocean waters drove all but the bravest swimmer to the local ponds, Bubble Pond being the favorite. The perfect conclusion to such an expedition to Bubble Pond was a walk to the Jordan Pond House for afternoon tea. (The Dunham family collection.)

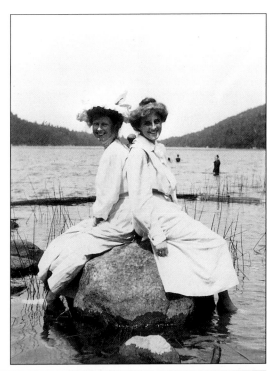

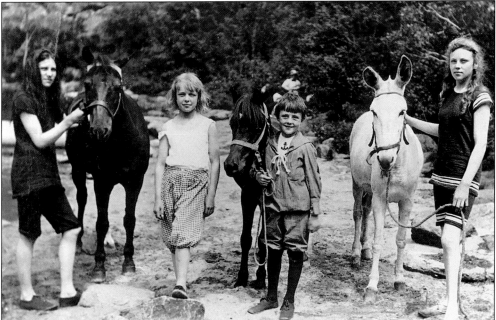

A relaxed foursome, these cousins pose with their animals: two Shetland ponies and Andrew Mac, a former circus donkey. Cottagers, especially those from the big cities, arrived each season with their selection of horses to take advantage of the labyrinth of trails throughout the island. Riding was considered good exercise in this pre–health club era. Though the children enjoyed outings such as this, they were not as pleased when their governesses dressed them in formal habits for their daily riding lesson. (The Dunham family collection.)

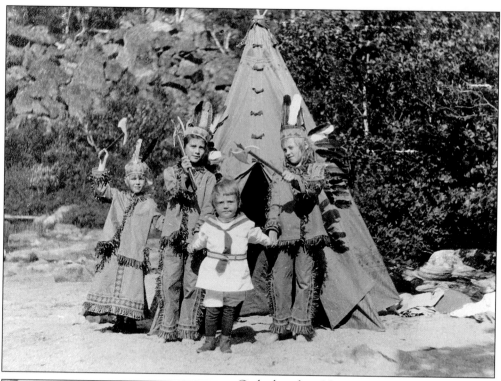

Garbed in their Native American costumes, cousins, from left to right, Peggy Hoe, Susan Herter, and Theodora Dunham, hold Edward Dunham Jr. hostage. Members of this group spent many summer mornings organized as the "Keewaydins," practicing their own customs and language. As Theodora Dunham remembered, "We trained ourselves to walk in the woods with our toes straight and each foot placed in the foot print of the person walking ahead." (The Dunham family collection.)

In this flashy rendition of Chanticleer, George Stebbins readies himself for flattering comments on his costume at the evening's costume party at an Ox Hill cottage. During this era, tableaux vivants (literary enactments) were a popular evening entertainment as an alternative to charades. Costuming could be very challenging. Musician Olga Samaroff Stokowski created her favorite Brunhild costume entirely out of kitchen utensils. (The Dunham family collection.)

New York stage actress Florence Reed strikes a slightly risqué pose against a rocky backdrop in 1917. As the Hudson River School painters had depicted the natural beauty of Mount Desert on the eve of the Civil War, so early filmmakers rediscovered the island's attraction as a setting for seven movies between 1916 and 1921. In this five-year period, well-known actors and actresses took part in silent dramas played out on the island's rugged coast. (The Liscomb family collection.)

In 1917, the *Bar Harbor Times* declared that "Bar Harbor and vicinity are furnishing scenes for the movies and many are the interested parties which have clustered about the entrance to the New Florence to see the actors of the Fox Film Corporation in wigs and whiskers, painted lips and eyebrows, set out to enact a number of scenes." The film being made that year was Fox's *Queen of the Sea*, a mythological melodrama in which the heroine learns that should she save four lives, she would be endowed with a mortal body and an immortal soul. Here, costumed cast members are being taken by boat to a Mount Desert shooting location. (The Liscomb family collection.)

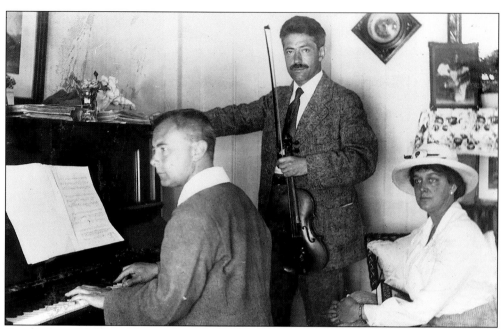

Stranded in the United States during World War I, many foreign musicians took refuge in Seal Harbor. With full descriptions of the island's beauties, musical educator and Seal Harbor resident Frank Damrosch coaxed his colleagues into summering at the small resort. This scene, showing Austrian violinist Fritz Kreisler (center) with his wife, Harriet Kreisler, and his colleague pianist Josef Hoffman, was commonplace during this period, as musicians gathered to prepare for concert tours, discuss artistic challenges, or simply to enjoy the area's deep woods, which reminded them of their homelands. (The Liscomb family collection.)

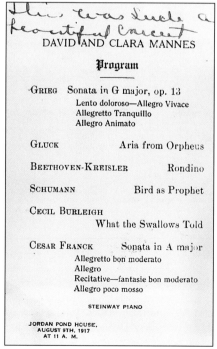

This was such a beautiful concert

DAVID AND CLARA MANNES

Program

GRIEG Sonata in G major, op. 13
 Lento doloroso—Allegro Vivace
 Allegretto Tranquillo
 Allegro Animato

GLUCK Aria from Orpheus

BEETHOVEN-KREISLER Rondino

SCHUMANN Bird as Prophet

CECIL BURLEIGH
 What the Swallows Told

CESAR FRANCK Sonata in A major
 Allegretto bon moderato
 Allegro
 Recitative—fantasie bon moderato
 Allegro poco mosso

STEINWAY PIANO

JORDAN POND HOUSE,
AUGUST 9TH, 1917
AT 11 A. M.

Before World War I, violinist David Mannes and his wife, pianist Clara Damrosch Mannes, organized concerts at the Jordan Pond House. "The wide porches which looked out on the mountain-rimmed lake" presented the perfect site for summer concerts. These concerts built a tradition and, by wartime, the Jordan Pond House was the location of frequent musical events. Violinist Fritz Kreisler, learning of the Seal Harbor cemetery's dire financial needs, joined with pianist Carl Freidberg to present a benefit concert. Not only did the concert raise over $700 for the local cemetery, but also the local paper reported that "the whole affair resembled a local gathering of friends with a cordial regard for each other, while summer and winter residents, musicians and amateurs alike, united in complete enjoyment of the evening." (The Dunham family collection.)

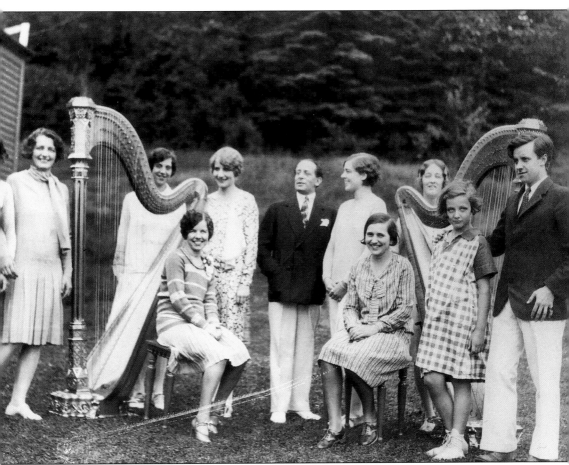

Eminent harpist Carlos Salvedo (center) gathers his troop of music pupils for a photograph. Like his colleagues pianists Leopold Godowski, Harold Bauer, Josef Hoffman, Ossip Gabrilowitsch, and Carl Freidberg, Salvedo used the summers to teach as well as practice. With students renting rooms in native homes and shops, the air was filled with music. Though practicing with their instruments relieved some of the tension brought on by the war, the artists found picnics, mountain climbs, and costumed charade games beneficial as well. As the war concluded, the friendships formed and cemented among the Seal Harbor music colony continued. Olga Stokowski, for one, made Seal Harbor her permanent summer home, arriving each year with a group of students. (The Liscomb family collection.)

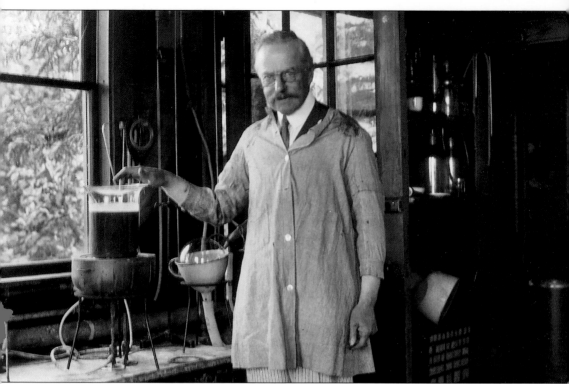

For many of Seal Harbor's naturalists, the island was an outdoor laboratory. Philadelphian John Redfield catalogued the island's flora in 1896. Natural scientists Edward Dana, Eugene Bristol, Samuel Clarke, and Henry Rowland were content to explore the island's unusual combination of mountains and oceans. New York biochemists Edward Dunham (above) and Christian Herter, on the other hand, needed not only a room of special equipment but also space for animals, such as geese, monkeys, and mice. Their laboratory adjacent to their cottages became central to their study of meningococcus. Family members were commandeered: children not only fed the lab animals and chased them when they escaped but also lent a hand when Dunham and Herter addressed the initial mailing for the *Journal for Biological Chemistry* at "Miradero." After Herter's death in 1910, "Miradero" laboratory continued to be used by its scientific owners, including Henry D. Dakin, the inventor of the Dakin antiseptic solution, and later, Dr. James B. Murphy, the eminent cancer researcher for New York's Rockefeller Institute. (The Dunham family collection.)

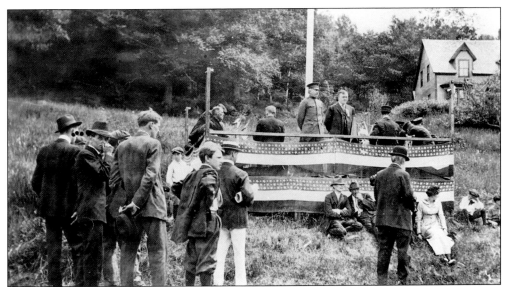

On July 4, 1917, the residents of Seal Harbor and neighboring towns gathered to celebrate Independence Day. Quite aware of their fellow Americans fighting the war overseas, this celebration took on an especially serious and patriotic air. Maj. Edward Dunham, in uniform on the speakers stand, stressed the importance of individual and community cooperation in fighting the war. (The Dunham family collection.)

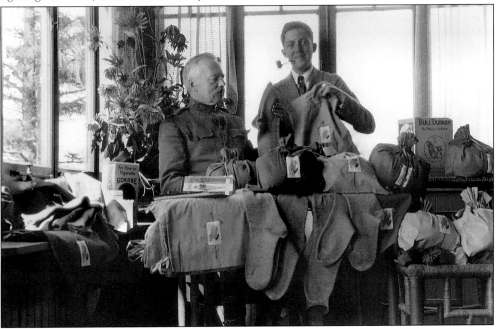

Practicing what he had preached on July 4, 1917, Dr. Edward Dunham, with his son Edward Dunham, assemble "comfort surprise bags" for the wounded in French hospitals. Through the American Fund for French Wounded program, residents packaged Bull Durham tobacco as a special surprise along with toiletries, clothes, chocolate, and stationary. Some of the summer residents' hand-knit products exhibited more goodwill than skill: a scarf, quietly discarded, was described as "resembling the state of Illinois in shape." (The Dunham family collection.)

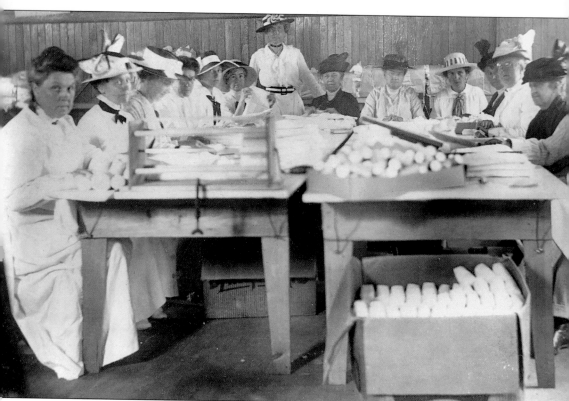

As early as 1915, Seal Harbor's summer and permanent residents were meeting at the local fire station hall to roll and organize medical supplies for shipment overseas. On this typical morning, 14 people from the community gather to prepare and bundle surgical dressings for French hospitals. Led by year-round residents Mrs. Herbert Goodwin, Mrs. Arthur Clement, Alice Stearns, and Mrs. Melvin Jordan, and cottagers Mrs. Edward Dunham and Mrs. William Sedgewick, the community's relief efforts blossomed. Between October 1917 and June 1918, the small Seal Harbor community sent overseas 319 pairs of hand-knit socks, 86 pairs of wristers, 10 hand-knit sweaters, 112 nightshirts, 73 day shirts, 61 bed jackets, 115 suits of pajamas, 17 child dresses, 52 pillows, 14 comfort bags, 7 quilts, 3 hand-knit afghans, 2 knit bandages, 2 hand-knit mufflers, 16 facecloths, and 7 baby bonnets. (The Dunham family collection.)

On a fair Maine afternoon, Julie, one of the cottage employees, sits on the terrace preparing her yarn for socks. Cottage help was involved in all stages of the war relief effort, from knitting to packaging bundles for the servicemen. Over the course of 18 months, the community women contributed over 500 pairs of homemade service socks. (The Dunham family collection.)

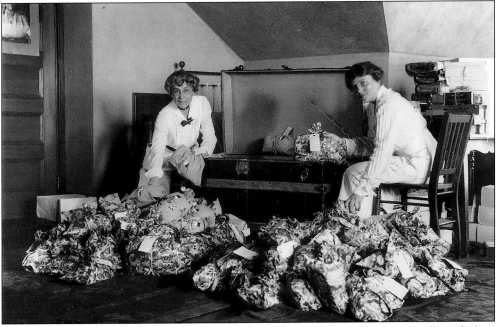

Once Seal Harbor's American Fund for French Wounded volunteers had collected their donations, the bundles were packed in trunks and shipped to Paris, where they were distributed to small hospitals. Theodora Dunham (right), busily packing beside her mother, later volunteered overseas during the war. At the age of 21, she drove one of the American Fund's supply trucks and saw firsthand that the donations, carefully prepared by her fellow Seal Harbor residents, reached their intended destinations. (The Dunham family collection.)

The war was eventually over, and Seal Harbor faced the future with optimism. Emblematic of that mood is this image of young Nelson A. Rockefeller arriving, bag in hand, at the Seal Harbor steamboat wharf. The vibrant personality that characterized his adult years is already evident. Born in Bar Harbor in 1908, he was the second son of John D. Rockefeller Jr. and Abby Aldrich Rockefeller. Following a career in family business and international diplomacy, he entered Republican politics, serving as governor of New York and as vice president under Gerald Ford. Each summer he returned to his Seal Harbor cottage "the Anchorage," built in 1941. (The Dunham family collection.)

Four

CHANGING TIMES: 1921–1947

These chauffeurs, standing outside J.B. Burke's garage in Seal Harbor, have plenty of reasons for smiling: the prosperous 1920s brought jobs to the area. Cottages changed hands, with businessmen replacing educators. Some newcomers were members of the Rockefeller family; others, such as Philadelphia soapmaker Samuel Fels, had no apparent connections; then came Edsel Ford and his relatives. Though only a few new cottages were built in the 1920s, the existing homes and estates provided ample opportunities for contractors and builders, gardeners, chauffeurs, butlers, maids, cooks, storekeepers, instructors, and clergymen. The summer season whirled with a busy social calendar for both summer residents and natives. The newly incorporated Seal Harbor Yacht Club and Harbor Club hosted hops, teas, tennis tournaments, and regattas for the cottagers' enjoyment; the burnt Neighborhood Hall was quickly rebuilt to become the hub of newly organized social events for the year-round residents. Between 1929 and 1947, this jolly atmosphere changed as the Great Depression and World War II brought escalating costs, shortened vacation times, and higher taxes. Fortunately for the year-round residents, the development of Arcadia National Park fueled the local economy. (Seal Harbor Library.)

While Emma Whitmore and Mr. Billings watched from their storefronts, businesses along the main street came and went. McIntire's (above), formerly Capt. William Cox's general store, went on to become Staples Drugstore and an IGA market before being torn down in the 1940s. A few townspeople modified their shops, according to the patron needs. Barber Eldridge "Pa" Bagley not only cut hair in his small bungalow-type shop just north of McIntire's but also ran a poolroom for several years and, on weekends, could be found playing in the local band. (Rockefeller Archive Center.)

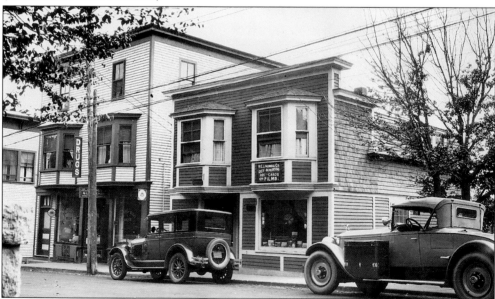

The advent of automobiles on the island gave summer and year-round residents the freedom to shop in neighboring villages, as well as their own. As the new Bar Harbor supermarket lured customers to its spacious aisles, Seal Harbor's business district began to shrink. Though Ralph Liscomb's gift and photo store (right) and MacKenzie's drugstore (left) closed after the war, the buildings still stand. Those across the street were torn down. (The Liscomb family collection.)

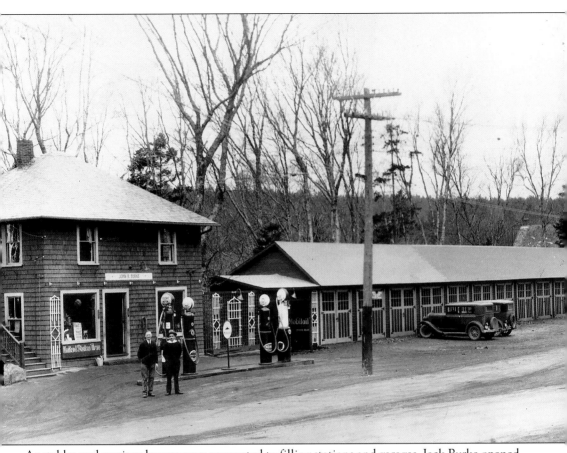

As stables and carriage houses were converted to filling stations and garages, Jack Burke opened a gas station and 12-stall garage in 1926 at the top of the hill above Seal Harbor's business corridor. The post–World War I era ushered in the honking horns, revving automobile engines, and vrooming motorboat sounds of the Roaring Twenties. Eventually, that noisy decade gave way to the quieter 1930s and 1940s, with fewer cottagers and renters. The wealthiest rusticators were in a position to help the island's threatened economy. Those natives fortunate enough to hold caretaker jobs were paid throughout each winter. One caretaker, Cecil Carter, recalled that his total annual income in the 1930s was $700. "It was tough, but we got by smelting, fishing, gardening, and digging clams." Others islanders found work locally in Arcadia National Park on the Rockefeller road-building projects. For some native families, however, survival meant leaving the island for employment at city factories. ("Caretakers for the Rich," *The Ellsworth American*, August 3, 1978.) (The Liscomb family collection.)

By 1922, Seal Harbor's Village Green, a sweeping lawn shaded by trees located just south of the village, had replaced the old Glencove Hotel. Working with the Seal Harbor Village Improvement Society, John D. Rockefeller Jr. purchased the five acres of land on which the hotel and a few businesses stood and donated the property to the town for a public park. The Improvement Society's Path Committee worked with landscape architect and Bar Harbor summer resident Beatrix Farrand to design a park where visitors and residents alike could meet on a balmy afternoon to enjoy a chat or await a ride with the next mail stage. (Maine Historic Preservation Commission.)

To John Tracy (left), a stonemason for B.W. Candage and Son, building the gutter for the Seal Harbor Village Green was a relatively easy task compared with the jobs of razing the old Glencove Hotel, moving several stores northward, filling in open cellars with stones, and landscaping the public park. Working for $4 per day, Tracy, Ernest Blaisdell, Elmer Hagarthy, and Irving Clement were just a few of the local men whose consistent efforts between 1919 and 1927 created the lush green lawn for Seal Harbor's community. (The Dunham family collection.)

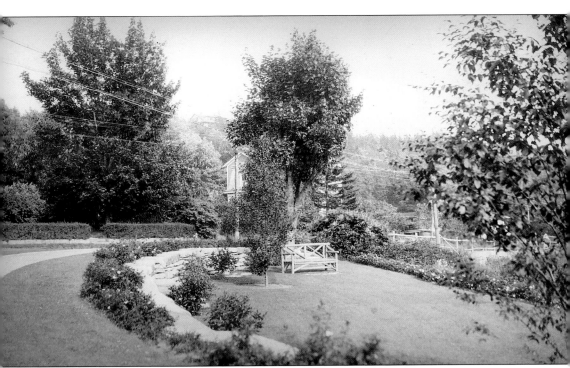

As a memorial to Dr. Edward Dunham, who had died in 1922, the Seal Harbor Village Improvement Society added to the public park the following year a terrace flanked with sweet-scented wild roses and wild blackberries. Seal Harbor's park now offered a variety of landscaped areas, a beach, and a ball ground for enjoyment in all seasons. A community Christmas tree, donated by Mrs. Howard Mansfield in 1928, kindled a holiday spirit each year. As Lyda Carter Noyes, for many years the postmaster, recalls, "Carolers gathered there on Christmas Eve and climbed into BW Candage's largest truck . . . with a small organ back of the cab for Evelyn Candage's accompaniment to the carolers. . . . We were driven over all the roads and streets stopping at each home and ending up back at the Christmas tree, followed by all the children in town, where we sang carols for as long as they wanted us to. The loaded truck included wrapped and heated stones near the organ, used by Evelyn to warm her fingers." (The Liscomb family collection.)

Coveted membership in the Old Timer's Club was limited to 10 Seal Harbor men. Pictured, from left to right, are Madison Snow, Frank Huston, Fred Mackenzie, Sam Candage, Eldridge Bagley, Doane Candage, Irving Clement, Jack Burke, Vernon Knapp, and Art Clement. This group could be counted on to decorate the community Christmas tree and hand out candy to the children, as well as to provide a good show when their basketball team, the Old Trippers, competed against the Knights of Pythias's Knightly Puffers. (The Liscomb family collection.)

In the off-season, Seal Harbor's year-round residents had time to relax. Typical is this gathering in which J. Burke, the Clement brothers, Sam Varnum, and F. Huston joined their off-island friends at a cabin for hunting. Some residents ventured into the forests and up the mountains; a few shopkeepers and hoteliers left for warmer climates; others began the flurry of activity associated with local church, fraternal, and social clubs. (The Liscomb family collection.)

The Seal Harbor Literary Club, begun in 1919, continued until the 1970s. This 1930s meeting included, from left to right, the following: (front row) Winifred Walls, Agnes Huston, and Margaret Liscomb; (middle row) Lenora McCrae, Hattie Lynam, and Mrs. Eddie; (back row) Catherine Butler, Ida Coston, Georgia Grindle, Ethel Alley, Nellie Martin, two unidentified women, Cynthia Clement, Lena Watson, unidentified, and Eunice Shaw. Though there were serious aspects to their weekly meetings, such as a prepared presentation, grammar lesson, and discussion of current events, the atmosphere perked up with the social hour and refreshments. (The Liscomb family collection.)

Members of St. Jude's Episcopal parish perform *Peter, The Rock*, a three-act Easter play, in 1932. Cast members shown, from left to right, are Hilda Dodge, Eliphalet Pettee, Lyda Carter, Loring Young, Doane Candage, Merton Pettee, Minnie McKenzie, and Paul Simpson. St. Jude's Helpers and the Congregational Church's Golden Rule Society sponsored plays and raised needed funds through annual fairs. (Lyda Carter Noyes.)

Proudly displaying their haul of cod are members of the Ford estate staff, including Irving Clement, superintendent (second from left) and his brother Arthur Clement (fourth from left). When off duty, the cottage help often gathered informally to fish offshore or in the island's ponds, many of which were stocked annually. Formal occasions, such as the annual Chauffeurs' Ball and Firemen's Ball, brought natives and the summer staff together, as well. (The Liscomb family collection.)

Tom Laughlin, one of the Ford estate's security guards, selected an appropriate costume to oversee his charges at this party on the Seal Harbor beach in 1923. The *Bar Harbor Times* described the festivities: "Last week the small folk of the summer colony enjoyed a gala day on the beach here. About thirty five little boys and girls, attired in charming costumes held races and marched to the music of a Victrola taken to the beach for that purpose. Little Miss Mayo dressed in a Dutch costume with real wooden shoes won a prize, also Miss Helen Clement dressed as Bo Peep and Miss Lanman as Peter Pan were prize winners. There were maids from Japan, clowns, a tribe of active Indians, and one Uncle Sam, and all enjoyed a very happy afternoon." (The Liscomb family collection.)

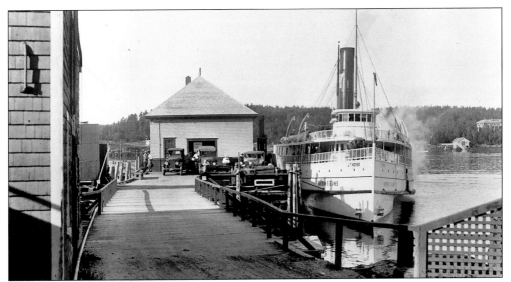

By the 1930s, the automobile had taken over as the primary transportation on the island, forcing the only remaining steamer, the *J.T. Morse* (right) to leave Maine waters for Coney Island, New York. In 1932, Northeast Harbor resident William Lawrence reflected on his trips to Maine: "It took twenty hours by rail and sea to reach here in 1870; now one can arrive from Boston in a third of the time." The introduction of airplane service in the 1930s between the two cities reduced travel time to two hours. (The Dunham family collection.)

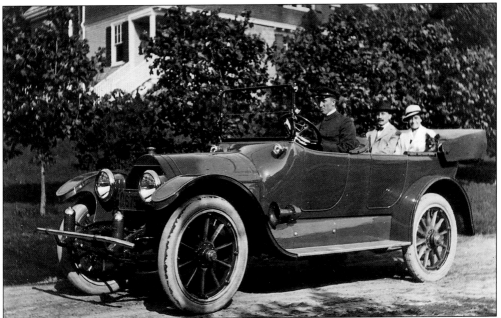

Though long fought as a menace to Mount Desert, once the automobile was allowed on the island, Seal Harbor's summer residents began to accept the change. With the son of the automobile king living on the same hill, it was no wonder that Ford cars were popular. Ocean Drive, with its scenic sampling of the island's birch and balsam-scented forests and unsurpassed views of ocean surf, was a prime choice for a long drive on a beautiful day. (The Dunham family collection.)

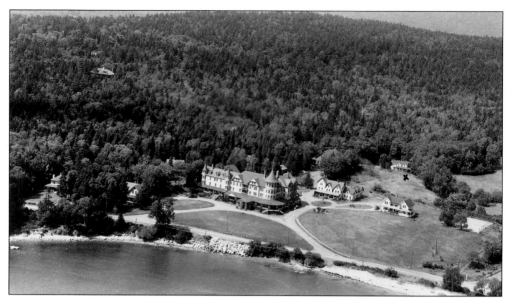

This aerial view shows the Seaside Inn (center) with the original Clement boardinghouse immediately to the right. The Clement family began boarding summer visitors during the 1870s and expanded to the Seaside Inn in 1892. The inn remained in the family throughout its history, finally succumbing to changing times. In 1963, the Greenrock Corporation, a Rockefeller family company, purchased the obsolete inn and demolished it that year. (Maine Historic Preservation Commission.)

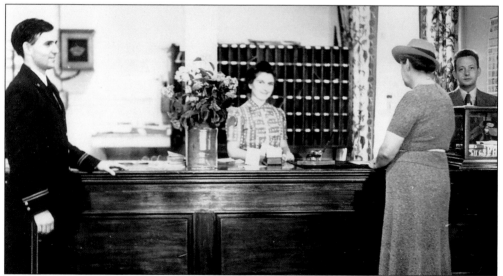

By the 1930s, rusticators had been vacationing at the gracious Seaside Inn for over half a century, many returning year after year, as did the staff. Hazel Sculley (center), receptionist, and Paul Windsor (left), the bellhop, made sure the guests were comfortable. The war years were memorable: guests turned over their ration books to the inn and, on V-J Day, "one of the managers opened the door from the office . . . and interrupted dinner with the radio broadcast. I recall many guests crying at their tables. That evening, the Seal Harbor fire truck raced back and forth with sirens, horns, and bells sounding." (*Seal Harbor Inn Reunion Book*, by Stephen C. Clement.) (The Liscomb family collection.)

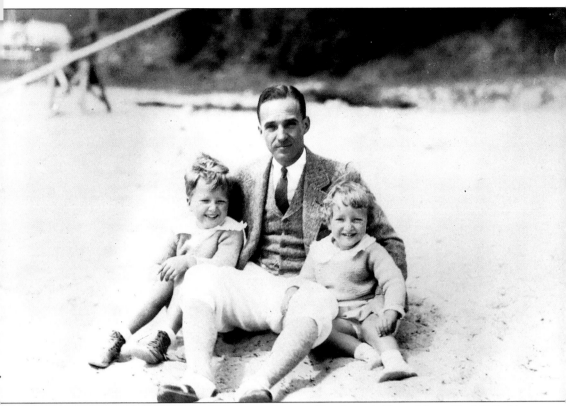

Edsel Ford sits on the beach at Seal Harbor with two of his four children, Henry Ford II (left) and Benson Ford. The only son of Henry and Clara Ford, Edsel Ford grew up with an intimate knowledge of the Ford Motor Company, where he started work in 1912 at the age of 19. In 1915, he became company secretary and, in 1918, he was elected president, a position he held until his death in 1943. During the 1920s, Edsel improved the famous Model T Ford and then replaced it with more advanced models. Before and during World War II, he led the company's major war production effort. (The Liscomb family collection.)

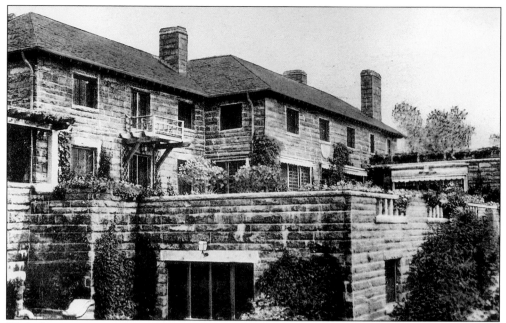

With their permanent home near Detroit and a winter residence at in Florida, Edsel and Eleanor Ford chose to spend their summers at Seal Harbor. In 1922, the Fords purchased 80 wooded acres near the crest of Ox Hill and commissioned Duncan Candler to plan a palatial estate to include a main house, guesthouse, playhouse, squash court, garage, stable, tennis court, and gardens. Constructed between 1923 and 1925, "Skylands" was first occupied by the Ford family in August 1925. Set into the hillside, the main house was built of Mount Desert granite by the local masonry firm B.W. Candage and Son. (Maine Historic Preservation Commission.)

Edsel Ford's love of vehicles extended from the road to the beach. Living just above one of only two sand beaches on Mount Desert Island gave Ford ample opportunity to take his children for a romp in his horse-drawn beach wagon. The Ford children often joined other youngsters constructing dams in vain attempts to block Stanley Brook. (The Dunham family collection.)

Immaculately dressed in a three-piece suit, Henry Ford chops wood at "Skylands," the estate of his son Edsel. With a genius for industrial organization, he started the Ford Motor Company in 1903 and quickly became the largest automobile manufacturer in the world, employing more than 100,000 people. He achieved this success by assembly line production. He loved to vacation in the outdoors, and the wooded acreage surrounding his son's Seal Harbor summer home provided a welcome retreat from the pressures of Detroit. (The Liscomb family collection.)

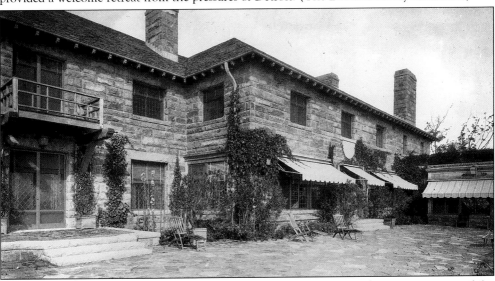

"Skylands" was aptly named by the Fords for its elevated location, with sweeping vistas of the ocean and offshore islands. Characteristic of Duncan Candler's work at Seal Harbor, a broad terrace provided the vantage point for these views, which could also be enjoyed from the living room, hall, and dining room on the first floor, and the principal bedrooms on the second floor. Reflecting its rocky hillside site, the rugged stonework of the main house was complemented by the naturalistic landscaping of Jens Jensen of Chicago, a Danish-born landscape architect. Of "Skylands," Jensen wrote in his book *Siftings*, "It is far from the prairies of the west to the rocky coast of Maine, to a different landscape with its different beauty."

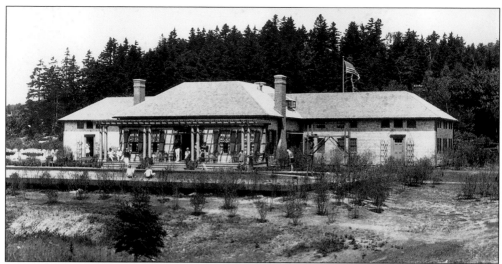

Recreational and social opportunities for summer residents were expanded in 1926 with the construction of the Seal Harbor Club, a project promoted by Seal Harbor cottagers Roscoe Jackson and Hunter McAlpin, and financially backed by Edsel Ford and John D. Rockefeller Jr. Built by members, the Colonial Revival–style quarters were designed by Duncan Candler to house a lobby, a lounge, and bathhouses. From the front of the central pavilion extended a terrace with a pergola-porch. This broad porch faced a large heated swimming pool. Five tennis courts were located nearby. (The Liscomb family collection.)

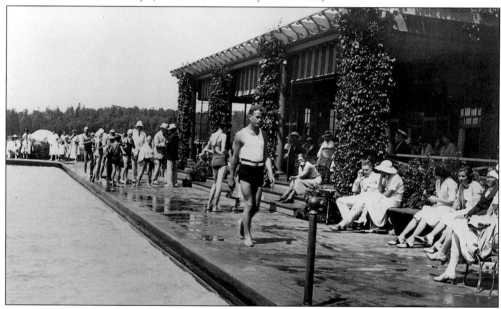

The carefree spirit of the Seal Harbor Club is captured in this 1920s photograph of members casually sunning themselves on the terrace in front of the swimming pool. Located at Bracy's Cove, the Seal Harbor Club was characterized in the *Bar Harbor Times* of May 26, 1926, as "one of the most delightful clubs to be found in any resort in America." A major attraction was the 40-by-100-foot concrete swimming pool, which the *Times* described as "an open air pool with mechanism for pumping in the sea water and with arrangements for frequent changing the water." (The Liscomb family collection.)

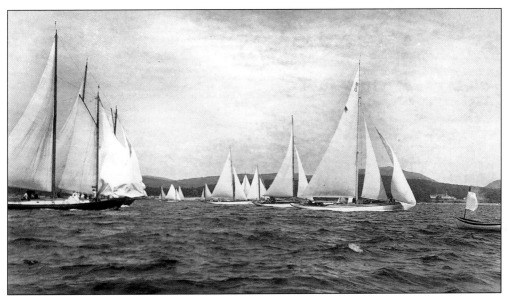

As the era of the great sailing yachts passed, racing smaller One-Designs became popular. The Seal Harbor Yacht Club held an annual regatta only once a year, but its sailors participated in the weekly racing series organized by the Northeast Harbor Fleet. Here, the Cruising class is approaching the start of a race. (The Dunham family collection.)

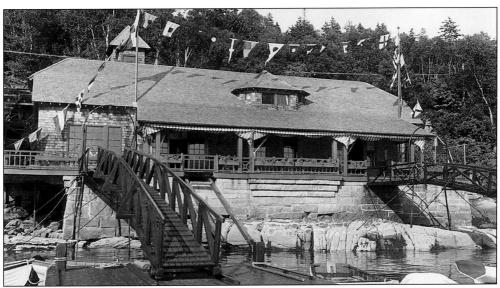

At the beginning of the 20th century, many Maine summer colonies established yacht clubs as attractive meeting places for their members. In 1912, the Hanna, Dunham, and Hoe families constructed this clubhouse for their own use from designs by Duncan Candler. With its granite foundation laid on a rock outcropping and its low, sweeping roof, the Seal Harbor Yacht Club is a classic example of the Shingle style. In 1923, summer residents purchased the building for a "yacht and boating club with social features in keeping with the simplicity of life which constitutes the charm of this place." Two years later, Candler was asked to plan the addition at the left to accommodate an enlarged dancing room, as well as improved facilities for serving refreshments. (The Dunham family collection.)

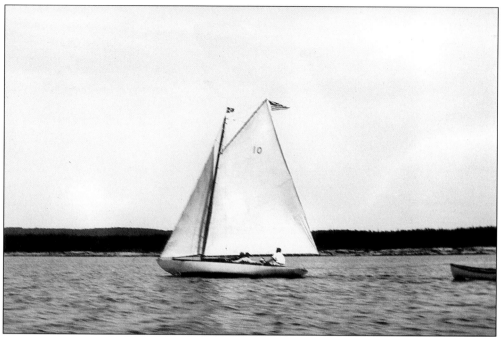

A smaller class than the 10 Meters was the B Class knockabouts. Here *Ace*, one of the original Manchester 17-footers designed in 1908 by B.B. Crowninshield and owned by Henry Stebbins is out for a day sail, towing a dingy almost as long as it is. (The Dunham family collection.)

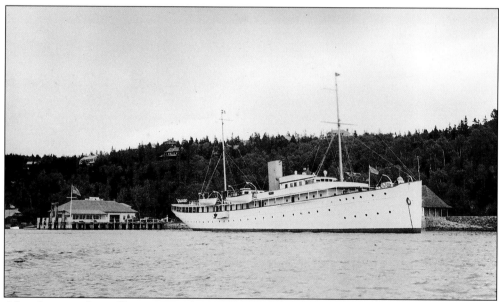

After the tragic loss of his steam yacht *Ara*, which went aground on Little Duck Island, Ernest Dane had the immense diesel yacht *Vanda* built at Bath Iron Works. Too large to enter Seal Harbor except at high tide, the 240-foot yacht transported the Danes and their guests overnight between Boston and Mount Desert Island in palatial accommodations and with sumptuous meals. The yacht generally lay at anchor off Clement's Point, immediately below "Glengariff." (The Dale Hadlock collection.)

Edward Dunham Jr., an eligible bachelor in the early 1930s, was often to be found either on a stag cruise or a day sail with Seal Harbor's debutantes, such as Katharine R. Jones, Clara P. Lynam, and Helen Brown. The log of the venerable *Zickie*, built in 1898, titles this photograph "Three little maids from school . . . are we, Pert as a schoolgirl well can be, Filled to the brim with girlish glee." (*The Mikado*.) (The Dunham family collection.)

Through the Roaring Twenties and into the quieter depression and war decades, teatimes remained an inviolable tradition, on the hillside, rocks, or cottage verandas. To the favorite pastimes of past eras, such as hiking, yachting, horseback riding, were added swimming and tennis at the Seal Harbor Club, and "hops" at local clubs. Gone were the days of rolling up the living room rug and holding informal dances, where the evening ended with a rollicking Virginia reel. (The Dunham family collection.)

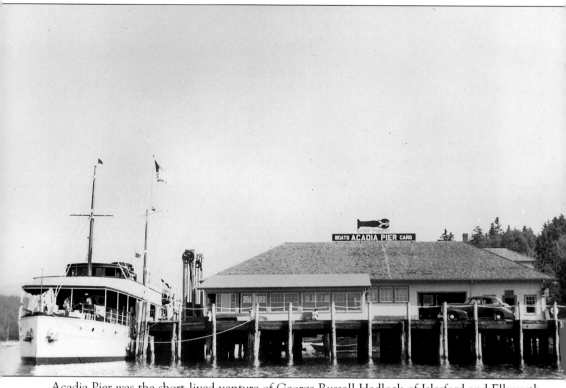

Acadia Pier was the short-lived venture of George Russell Hadlock of Islesford and Ellsworth, an attorney, politician, and entrepreneur. In the mid-1930s, Hadlock acquired the former steamboat wharf and transformed it into a seafood restaurant and summer boating business. A period advertising brochure proclaimed that "Acadia Pier, extending out into Seal Harbor, commands a view of mountains, cottages, ocean, islands, and all passing yachts." The sightseeing boat (left) toured the harbor and nearby islands with fares ranging from 25¢ to $2, depending on the length of the trip. (The Dale Hadlock collection.)

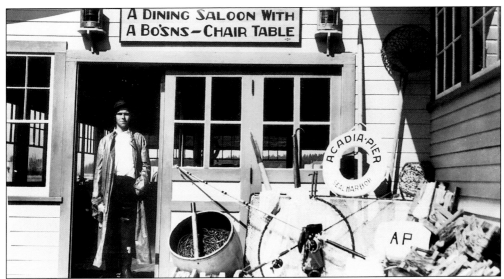

The Quarter Deck restaurant on Acadia Pier featured shore dinners from $1 to $1.75. Owner George Hadlock hired women from his native island of Islesford to cook and serve generous meals of lobster, clams, and fish. A local fisherman stands in the door of the restaurant's glassed-in porch, which accommodated dinner and dancing parties. The sign over the doorway advertises the Quarter Deck, which a brochure described as "the New Nautical Dining Room with its Bosns' Chair Table and other novel features appropriate and popular for Dinner Parties and Banquets." (The Dale Hadlock collection.)

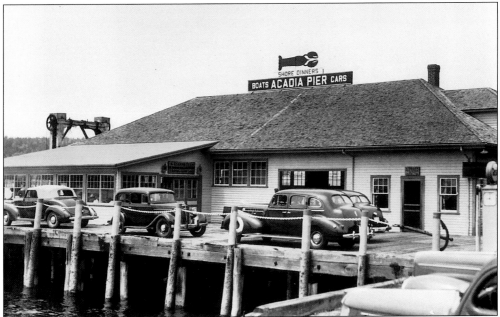

Acadia Pier fell victim to the gas rationing that curtailed tourist travel during World War II. By the close of the war in 1945, the old steamboat wharf was in poor condition, and owner George Hadlock began dismantling and removing buildings. The Seal Harbor community acquired the pier and rebuilt it for the town dock, which is still in use today. (The Dale Hadlock collection.)

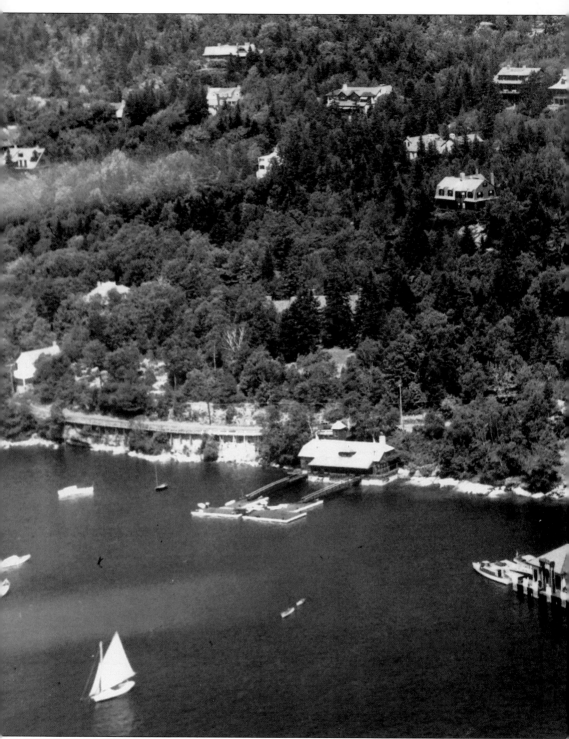

An aerial photograph of Ox Hill illustrates how well George Cooksey's vision of a Seal Harbor summer colony had succeeded during its first 50 years. The hill is dotted with both modest and palatial cottages, and the waterfront is lined with docks. Along the shoreline, from left to right,

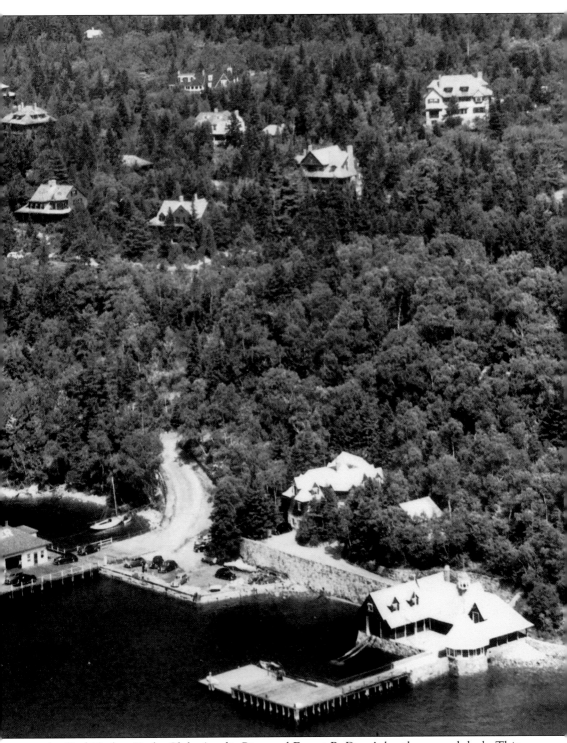

are the Seal Harbor Yacht Club, Acadia Pier, and Ernest B. Dane's boathouse and dock. This picture was taken *c.* 1940 by A. Neal Lane, a photographer who worked in Portland from 1931 to 1940. (The Dale Hadlock collection.)

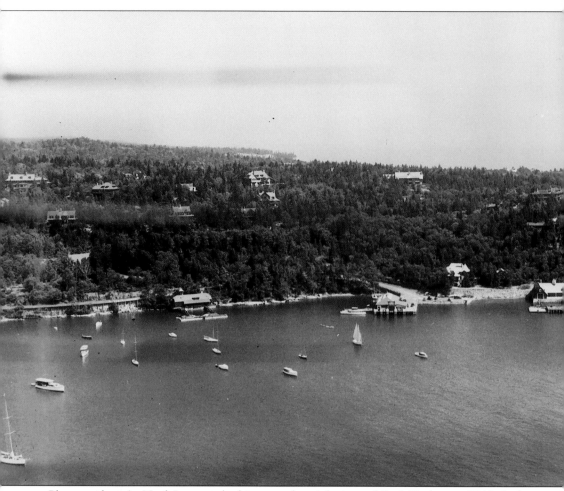

Photographer A. Neal Lane took this second aerial view of Seal Harbor c. 1940, looking across Ox Hill with the ocean in the background. Less clearly seen from this angle are the summer cottages nestled into the tree-covered hillside. However, the Seal Harbor Yacht Club, Acadia Pier, and Dane boathouse and dock are highly visible waterfront landmarks. In the 1930s, summer resident Gilbert H. Montague, a New York attorney, wrote of the community, "Serenity is the quality that one can always find in these hills and shores and open stretches of water and softly enveloping fogs. How many financial disturbances and monetary changes and economic revolutions and political spasms this old island has outlived." (The Dale Hadlock collection.)

Five

CREATING A PARK

Like other Mount Desert communities, Seal Harbor incorporated its Village Improvement Society in 1900 to better build and maintain hiking trails for summer recreation. One of the attractions of the Jordan Stream Trail was the trout brook, shown in this 1915 photograph by Charles A. Townsend. In 1916, most of the hiking trails were incorporated into the newly founded national park. Around that time, one writer noted, "Just as Glacier is the national park of the trail rider, so Lafayette (Acadia) is the national park of the trail walker. A network of trails discloses its beauties." (Maine Historic Preservation Commission.)

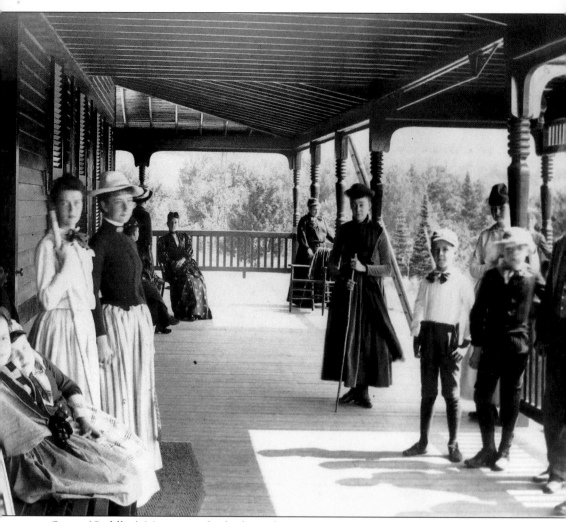

Green (Cadillac) Mountain, the highest elevation on the Atlantic coast, has been a beacon to explorers for hundreds of years. City dwellers, such as those in this 1880s photograph, traveled far to follow the paths first trod by the Wabenaki Federation of Native Americans. The Wabenaki migrated annually to the island, which they called *Pemetiq,* meaning "the range of mountains," for routine summer activities: fishing, clamming, berry picking, and trapping. Might we imagine that they, too, enjoyed the scenery before returning to their mainland villages for the harsh winter? The network of paths they created was extended by Seal Harbor's settlers and then by visitors like John Redfield, Joseph Allen, Thomas McIntire, and others until, in 1941, there were nearly 300 trails. (Walter K. Shaw Sr.)

The path shown in this photograph by Charles A. Townsend was described by Jordan Pond House owner Thomas McIntire in 1915: "To Seal Harbor come yachting parties to take the delightful excursion to Jordan Pond House for lunch or dinner. There are many roads and trails either for riding or walking; one, the seaside trail, leads through a beautiful growth of large trees. It is graded almost the whole two miles to the pond, making it easy for one who can do any walking." (Maine Historic Preservation Commission.)

Before 1915, the sole way to explore more remote areas of the forests and higher peaks was on foot. The towns' improvement societies and private citizens created crude footbridges, rock staircases, and iron rungs to help hikers traverse streams and crevices and scramble up cliffs. The broad gaps in this bridge on the trail to Jordan Pond often frightened little tykes, especially those teased by older siblings. (The Dana family collection.)

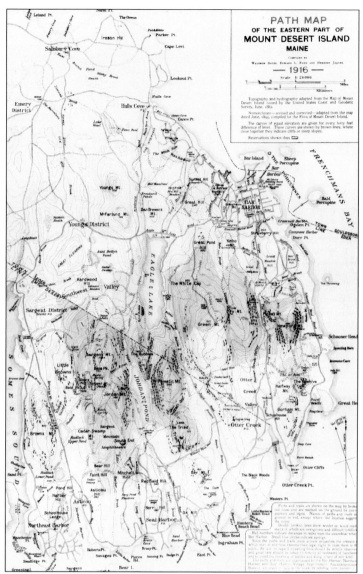

PATH MAP
OF THE EASTERN PART OF
MOUNT DESERT ISLAND
MAINE

— 1916 —

At the start of the 20th century, the island's prosperous resorts attracted nature lovers and land speculators alike. Recognizing the threats by developers and loggers to the forests' "wildness," Northeast Harbor summer resident Charles W. Eliot gathered representatives from the neighboring Village Improvement Societies to form the Hancock County Trustees of Public Reservations (the Trust). Although a Maine law to "acquire, hold, and maintain and improve for free public use lands in Hancock County" was enacted in 1903, five years passed before the Beehive and the Bowl, a 520-foot-high mountainous tract south of Bar Harbor, became the trust's first holding. By 1916, these holdings included some 5,000 acres (shaded areas), primarily mountaintop, all donated by public-spirited citizens. Realizing that they lacked a continuous source of funds to maintain the holdings, Eliot and enthusiastic outdoorsman George Bucknam Dorr, a Bar Harbor summer resident, spent two years convincing the U.S. Congress and Pres. Woodrow Wilson to accept the 5,000 acres, with its 250 miles of trails, as the Sieur de Monts National Monument. This first step led to the creation of Lafayette National Park in 1919. (Acadia National Park.)

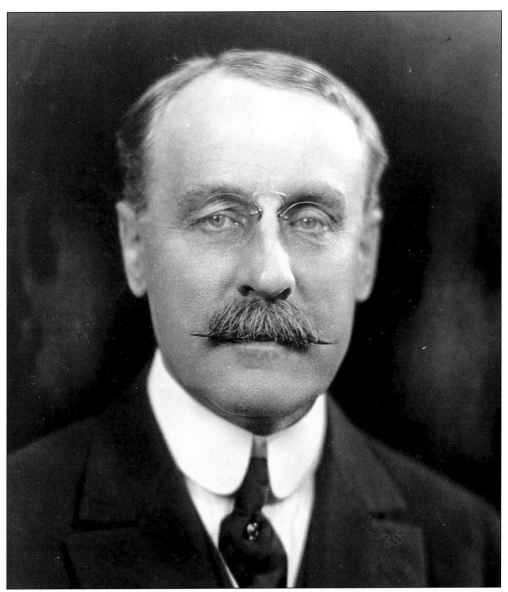

The process of soliciting land donations and convincing state and national leaders to create the East Coast's first national park required the complementary leadership of three prominent summer visitors: George L. Stebbins (above), Charles W. Eliot, and George B. Dorr. Stebbins, manager of Cooksey Realty in Seal Harbor and treasurer of the Trust, took quick action in 1910 to organize a group of Seal Harbor summer residents to purchase 3,600 acres, including all of the Southern Bubble, Pemetic Mountain, and the western side of Green (Cadillac) Mountain. This group donated all the non-agricultural and residential land, some 2,000 acres, to the Trust. Two years later, Stebbins and George Cooksey collaborated with Charles Eliot and Northeast Harbor residents to raise $7,000 to buy an additional 2,000 acres, including Jordan and Sargent Mountains. This land, safely out of developers' reach, was donated to the Trust. It was then Eliot's guidance and connections complementing Dorr's political savvy that transformed the Trust's holdings to a national monument and, shortly thereafter, to a national park. (Seal Harbor Library.)

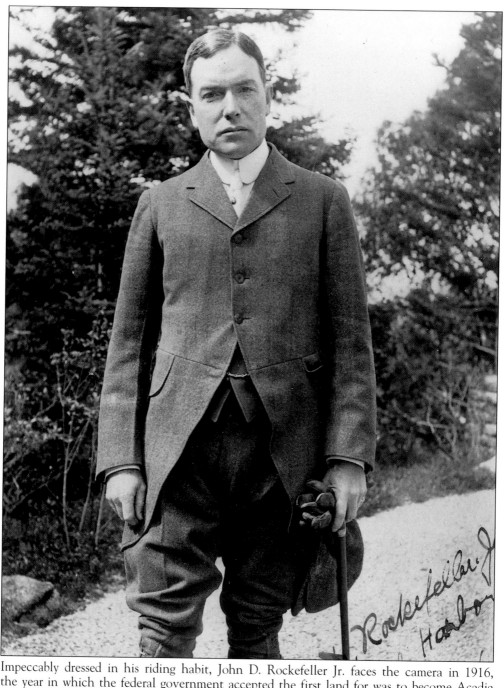

Impeccably dressed in his riding habit, John D. Rockefeller Jr. faces the camera in 1916, the year in which the federal government accepted the first land for was to become Acadia National Park. Rockefeller played a central role in the park's creation, donating 2,700 acres of land. Moreover, according to Nancy Newall in her book *A Contribution to the Heritage of Every American* (1957), Rockefeller "conceived an idea to make the area more than a preserve; he originated plans to build a road system to open up the lovely vistas of Acadia to visitors. Pursuing an old enthusiasm, he spent hours with surveyors and engineers in designing and constructing some sixty miles of roadways and bridges." (The Liscomb family collection.)

Charles P. Simpson (above) of Sullivan served as the first engineer for the Rockefeller carriage road system, from 1916 until his retirement in 1922. In planning a road, John D. Rockefeller Jr. first established the route by using maps and his personal examination of the area. Then, according to "Building Acadia's Roads and Bridges," an essay by Simpson's grandson, Simpson "surveyed the ground, studied alignment, prepared construction documents, did the final layout and supervised construction," all in close consultation with Rockefeller. Simpson came to work for Rockefeller at the age of 67. He had a long list of previous engineering successes, including the Kebo Valley Golf Club in Bar Harbor and the railroad between Ellsworth and Machias. (Rockefeller Archive Center)

Paul D. Simpson assumed the role of chief engineer for the Rockefeller carriage roads after his father, Charles P. Simpson, retired in 1922. He appears in a 1929 photograph with his son Charles P. Simpson II. He was well qualified for the work, inheriting knowledge of the close collaborations between John D. Rockefeller Jr. and his father, in addition to his own professional training as a civil engineer. He carried on until the carriage roads and bridges were completed in 1940, after which he remained as an engineering consultant to Rockefeller until the 1950s. (Rockefeller Archive Center.)

When John D. Rockefeller Jr. set out to build his carriage road system, he approached the project with a thorough knowledge of road-building technology, as well as previous experience at his family estates in Ohio and New York. To construct roads through the rough terrain of Mount Desert, Rockefeller employed the latest equipment. Here, a steam-powered crane was used to move large rocks from one of the carriage routes. (Rockefeller Archive Center.)

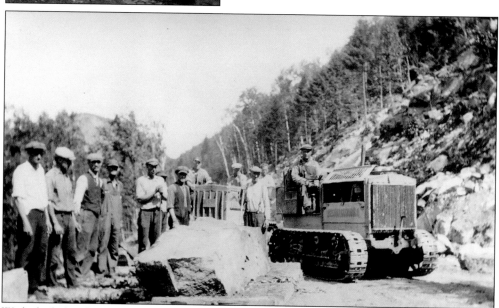

With the help of a tractor, a crew moves copingstones into place along the West Jordan carriage road. John D. Rockefeller Jr. used these rough granite stones to define the perimeter of the highway for safety reasons, while adding a natural touch. Ann Rockefeller Roberts points out in *Mr. Rockefeller's Roads* that "these long lines of stone teeth were placed last, after the drainage system had been installed and the road surface laid." (Rockefeller Archive Center.)

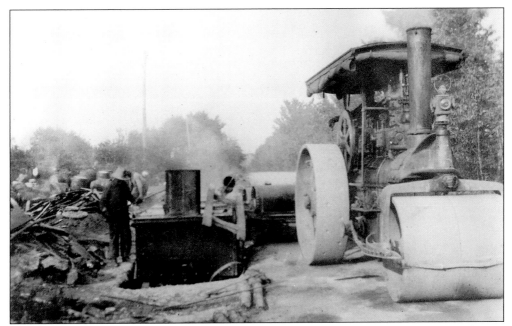

John D. Rockefeller Jr. constructed his carriage roads in three layers: a broken rock foundation, a middle layer of smaller stones, and a finish surface of fine gravel. In order to bind the layers and create a smooth surface, Rockefeller's construction crews used horse-drawn road rollers, which were replaced in 1922 by the heavier steam road roller shown here. (Rockefeller Archive Center.)

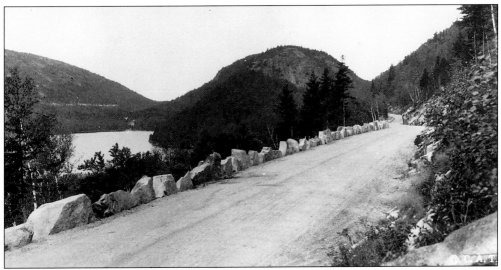

As the automobile came into widespread use after World War I, John D. Rockefeller Jr. recognized the need for a limited system of motor roads in Acadia National Park to provide greater public access. Over the highly vocal objections of some Mount Desert summer residents, Rockefeller embarked upon a road-building program in 1922 by pledging $150,000 to develop the Jordan-Bubble Pond Road (above), connecting Bar Harbor with the Jordan Pond House. Built between 1923 and 1924, this scenic road featured the Rockefeller hallmark of the protective granite copingstones. (Maine Historic Preservation Commission.)

Between 1917 and 1928, William Wells Bosworth designed nine bridges for the Rockefeller carriage road system. A prominent New York architect, Bosworth enjoyed a personal friendship with Rockefeller, for whom he designed extensive gardens at the family's estate in Pocantico Hills on the Hudson, as well as at the New York City home. Early in his career, Bosworth had worked for landscape architect Frederick Law Olmsted Sr., excellent preparation for his collaboration with Rockefeller in blending a series of beautifully crafted stone bridges into the rugged terrain of Mount Desert. (Maine Historic Preservation Commission.)

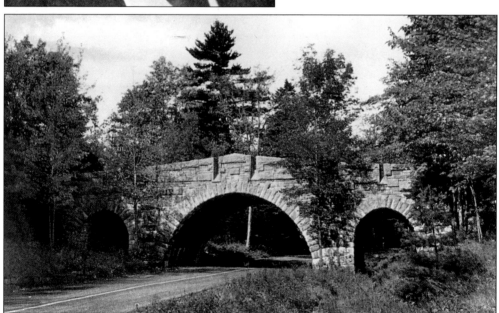

One of the more visible of the Rockefeller carriage road bridges is the Stanley Brook Bridge (1933). This graceful, triple-arched stone bridge was designed by Charles Stoughton, with working drawings and construction supervision provided by Paul Simpson. The central arch carries the Barr Hill–Day Mountain road over the Stanley Brook motor road; one side arch spans Stanley Brook and the other the Seaside Trail, the forested walkway between Seal Harbor and Jordan Pond. (Maine Historic Preservation Commission.)

New York architect Charles W. Stoughton (right) is shown in this 1931 photograph standing next to Chip Simpson, whose father, Paul D. Simpson, was the local engineer supervising the construction of the Rockefeller carriage road system. Between 1929 and 1933, Stoughton planned six stone bridges for Rockefeller, including Duck Brook, West Branch, Amphitheater, Cliffside, Jordan Pond Road, and Stanley Brook. Stoughton came to the attention of John D. Rockefeller Jr. through the architect's designs for bridges on the Bronx River Parkway. (Rockefeller Archive Center)

Seaside Inn employees, elated after having climbed Pemetic Mountain, reflect the informality of the post–World War II era. Unlike their 1870s predecessors, described as wearing "wide brimmed hats and picturesque costumes of red and blue flannel, cut short above the feet and ankles, which, in turn, are incased [sic] in stout walking shoes," these young people are comfortable wearing short hair and casual clothing. ("Mount Desert," *Harper's New Monthly Magazine*, August, 1872.) (Stephen C. Clement.)

117

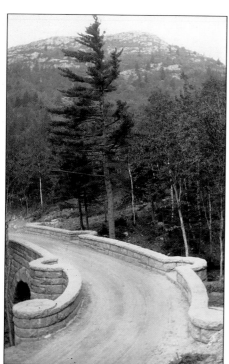

In 1925, John D. Rockefeller Jr. commissioned the Waterfall Bridge on the Sargent Mountain carriage road. Located on the west side of Parkman Mountain, this gracefully curving bridge was designed by William Welles Bosworth and was built by Byron W. Candage at a cost of $44,104. Ann Rockefeller Roberts describes the setting: "Especially captivating is the view from Waterfall Bridge, where Hadlock Brook falls forty feet down the mountainside and then cascades over rocks and under the bridge before continuing on to the Upper Hadlock Pond." (Rockefeller Archive Center.)

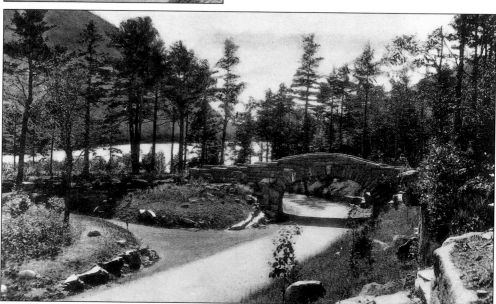

The Bubble Pond Bridge carries the Rockefeller carriage road over the motor road in Acadia National Park. In 1926, John D. Rockefeller Jr. commissioned architect William Bosworth to plan an arch bridge for this location, but the designs were rejected by the National Park Service as being too "citified." The following year, National Park Service architects Daniel Hall and Thomas Vint proposed a more rustic stone bridge, which was built in 1928 under the supervision of Pringle Borthwich, a Philadelphia mason. Despite the rejection of his own architect's drawings, Rockefeller was actively involved in this project and paid the construction costs of $21,301. (Maine Historic Preservation Commission.)

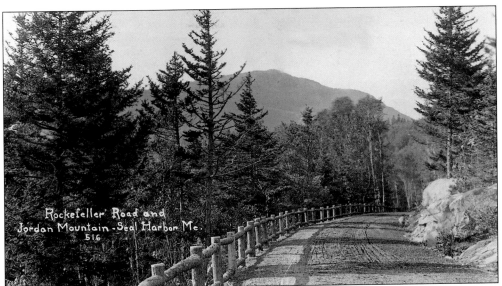

One of the first sections of the Rockefeller carriage road system, which took nearly three decades to complete, appears in this 1916 photograph. It opened up a tableau of Jordan Mountain on the approach from Seal Harbor, and a return trip revealed a panorama of the harbor and the islands beyond. John D. Rockefeller Jr. envisioned a more extensive scheme. Ann Rockefeller Roberts explains: "He also wanted to connect the northern and southern sections of the park so it [the road system] would extend from shore to shore. In short, he wished to make available to everyone the spectacular views of mountain and ocean, the vistas of lakes and forests, and the vignettes of meadows and woodland streams." (Maine Historic Preservation Commission.)

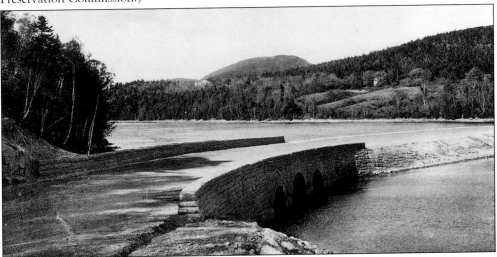

During the 1920s and 1930s, John D. Rockefeller Jr. and landscape architect Frederick Law Olmsted Jr. collaborated in the planning of a motor road system for Acadia National Park. Rockefeller and Olmsted concentrated primarily on Green (Cadillac) Mountain, Ocean Drive, and the Stanley Brook road to Jordan Pond. Other features, such as the Otter Creek viaduct shown here, were created by the National Park Service. The rustic stonework of the Otter Creek Bridge blending into the landscape reflects the influence of the Rockefeller carriage road system and its bridges. (Maine Historic Preservation Commission.)

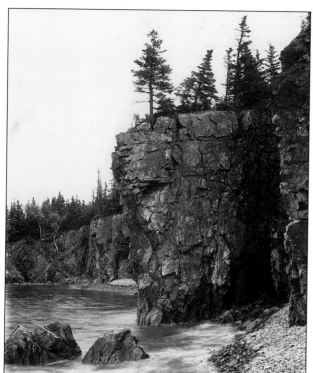

The rocky coastline of the Mount Desert region is depicted in this 1890s photograph by Henry Rowland, an early Seal Harbor summer resident. Some 30 years later, in his 1924 essay "Mount Desert, the Unspoiled," William Warren, dean of Boston University, described such dramatic scenery in the following words: "On Mount Desert Island, where cliff borders the sea and forest borders the cliffs, you still feel yourself in the presence of nature; man is present not as exploiter and concessionaire, but, in Bacon's wise phrase, as minister and interpreter." (Seal Harbor Library.)

By the time Henry Rowland took this photograph of Long Pond in the 1890s, the commercial center of Seal Harbor had moved from here to the present-day village. Only the Callahan House, barely visible at the left, stood as a reminder of Stephen Southard's store and post office, and the school, which had flourished in the mid-19th century. After his arrival in 1910, John D. Rockefeller Jr. acquired the land around Long Pond for its scenic value. Northeast Harbor summer resident Charles Eliot wrote Rockefeller in 1916 that "the view up the Pond toward the hills" provides "the most beautiful view on the Island." (Seal Harbor Library.)

SEAL HARBOR LIVERY STABLE

FRANK E. DAVIS

Convenient to Jordan Pond and Seal Harbor

Telephone Seal Harbor 4-3

Runabouts, Surreys, Buckboards and Saddle Horses

For Hire by the Afternoon or Day

TARIFF

For single runabout for the afternoon without driver .	$5.00
For single horse and cutunder with driver for afternoon .	7.00
Short trips by arrangement	
For three-seated buckboard with driver for afternoon	
Four passengers	8.00
Each additional passenger	1.00
For surrey and pair with driver for full tour of Rockefeller Roads, including Barr Hill, Long Pond Meadows, Asticou, Jordan Pond and return	8.00

Despite growing competition from the automobile, Frank E. Davis was able to maintain his Seal Harbor Livery Stable into the 1930s by supplying horses, carriages, and buckboards for those touring the Rockefeller carriage road system. Describing the Mount Desert tradition of buckboard rides in 1892, Sherman's *Guide to Bar Harbor* stated, "The gentle swaying motion of the board while traveling at full speed over hilly roads is simply delightful." (The Dunham family collection.)

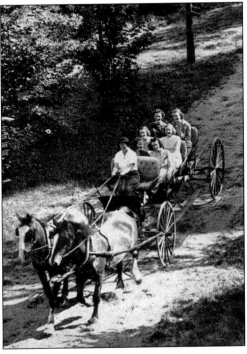

The buckboard ride tradition was still in force in 1942, when this photograph was taken. The brochure in which this picture appeared proclaimed: "Let's ride behind a pair of chestnut bays, like grandma used to do. The beautiful carriage roads of Acadia National Park, constructed through the beneficence of John D. Rockefeller Jr., have come into their own this summer, ranging some thirty miles through virgin countryside of unspoiled New England charm." (Maine Historic Preservation Commission.)

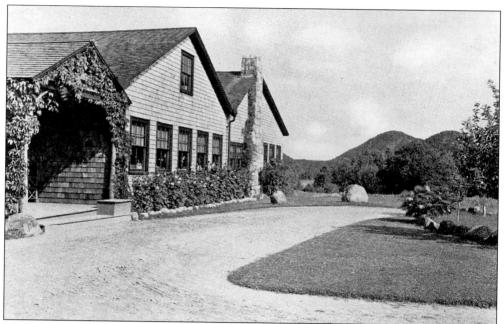

The Jordan Pond House, pictured here in 1915, was purchased by John D. Rockefeller Jr. in 1928, along with the surrounding lands, all later donated to Acadia National Park. Nellie and Thomas McIntire continued as proprietors, serving patrons with their famous teas and popovers. In time, lobster dinners became more popular with park visitors than the chicken entrees. On those typical Maine foggy days, a crackling fire in the massive stone hearth and hot drinks warmed disappointed tourists. (Maine Historic Preservation Commission.)

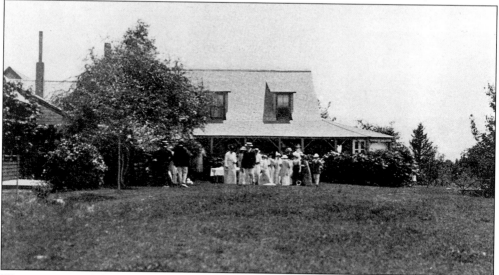

Women in pastel dresses and men in coats and ties visit the Jordan Pond House to "take tea" on a summer day in 1915. During the Great Depression, wealthy resorters continued to patronize the place, but the gas rationing of World War II kept most of the summer residents at their winter homes. Those who did venture down east found the Jordan Pond House open for afternoon tea with a sole waitress, Mrs. Warren Hyten, the McIntire's granddaughter, who served 4,192 guests in one summer. (Maine Historic Preservation Commission.)

On August 21, 1945, just days after the World War II had ended and gas rationing had been lifted, over 800 guests arrived at the Jordan Pond House to offer congratulatory thanks to Nellie and Thomas McIntire, shown here with their daughter Marion (center), for their 50 years of gracious management of the teahouse. Young and inexperienced when they served 54 dinner guests in 1895, they turned the weather-beaten farmhouse into one of the park's most famous features, frequented by presidents, royalty, foreign dignitaries, artists, as well as eager tourists. (Great Harbor Collection, Northeast Harbor.)

Though the pace of life had quickened by the late 1940s, some families resolutely retained traditions of simpler times: picnics on the rocky shores, daylong hikes over the mountains, and carriage rides ending with tea and popovers, with this spectacular view of the Jordan Pond, "a gem set in the hollow formed by the slopes of Sargent and Jordan [Penobscot] Mountains on the one side and Pemetic on the other." (Maine Historic Preservation Commission.)

Taken in the 1890s, Henry Rowland's dramatic photograph of clouds over the meadow above the Seaside Inn at Seal Harbor is reminiscent of pre–Civil War paintings by the Hudson River School artists, who first depicted the landscape of Mount Desert. Views such as this attracted summer visitors to Seal Harbor and continue to do so. As John Wilmerding writes in *The Artists' Mount Desert*, "As the late 20th century yields to the 21st, the Mount Desert landscape remains an enduring presence, with a power no less spiritual than physical." (Seal Harbor Library.)

Charles A. Townsend photographed this unspoiled sweep of Mount Desert in 1915. Taken from Sargent Mountain, this picture shows Jordan Pond on the left, with the Jordan Pond House in the clearing above it. Beyond is Seal Harbor and, on the right, Long Pond. Dean William Warren of Boston University noted in the *Bar Harbor Times* of March 19, 1924: "Though the Island has 15 or 16 mountains, some of them high enough to give far views of Grand Manan and Mount Katahdin, not one of the skylines is broken with tower or mountain house." (Maine Historic Preservation Commission.)

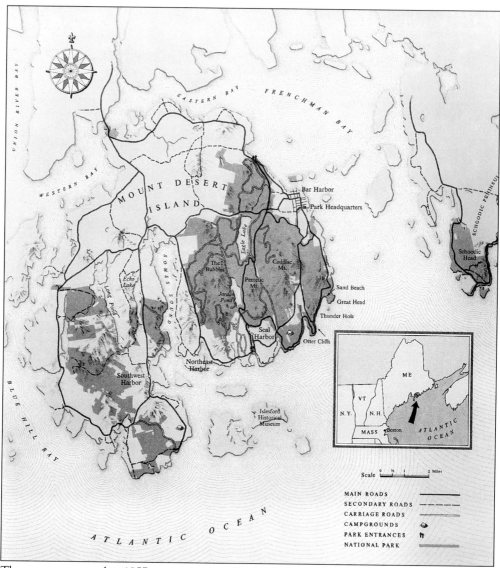

The gray areas on this 1957 map represent the land acquired in the Mount Desert region by Acadia National Park during its first four decades. The map appears in Nancy Newall's *A Contribution to the Heritage of Every American*, which chronicles the conservation activities of John D. Rockefeller Jr. According to the book, "To preserve the woodlands, the remarkably varied wildlife, the magnificent views, alert citizens formed a group to acquire and redeem most of the primitive terrain and preserve it." First held as a public trust, the land was accepted by the United States as Sieur de Monts National Monument in 1916, became Lafayette National Park in 1919, and had its name changed to Acadia in 1929. (Maine Historic Preservation Commission.)

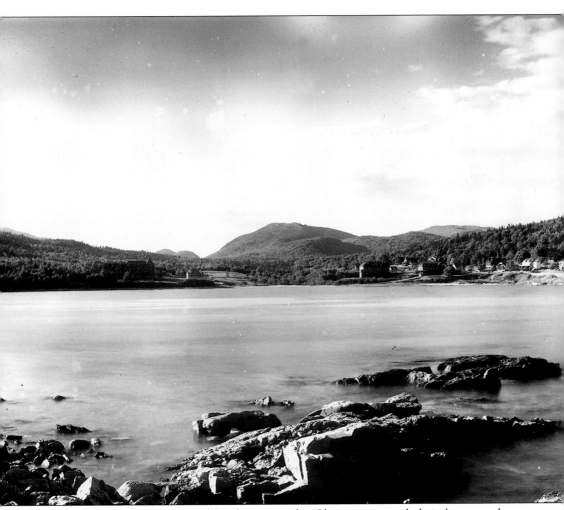

While much had changed in Seal Harbor since the Clements opened their homestead to boarders in 1869, certain characteristics remained. Joseph Allen Jr., a longtime Seal Harbor vacationer, reminisced that "there are two elements that go to make the best kind of vacation resort, which are of equal importance. Most of us would perhaps put first the advantages due to Nature—the beauty of the region and the variety of the outdoor recreations offered, but of great importance also is the man-made character of the place, its conveniences, its simplicity of living, its serenity and opportunity for real refreshment, away from the hurry and restlessness of modern high pressure life. Few regions combine these two elements as completely as does Seal Harbor with mountains and sea, forest and ocean shores, scenic automobile drives and equally delightful carriage roads and bridle paths, its natural beauty and variety of outdoor recreation can hardly be surpassed anywhere." (*Bar Harbor Times*, August 20, 1959.) (Seal Harbor Library.)

ACKNOWLEDGMENTS

The authors are indebted to the following people and institutions for lending us their photographs and assisting us with identifications: Adelbert Liscomb, Maggie Taylor, Gordon Shaw, Henry and Becca Stebbins, Eleanor Clement, Stephen Clement, Pauline and William Willis, Lewis and Elizabeth Gordon, Helen Cooksey, Lyda Carter Noyes, Dale Hadlock, Elisabeth Pulverman, the Seal Harbor and Northeast Harbor Libraries, the Great Harbor Collection, the Rockefeller Archive Center, the Maine Historic Preservation Commission, and Acadia National Park.

Several people helped us investigate Seal Harbor's past by identifying photographs, recalling stories, searching for details, and checking our information for accuracy. For this assistance, we would like to thank the following: Deborah Burch, Robert Pyle, Louise Libby, Carol Dyer, Brooke Childre, Margie Coffin, Edward Dunham III, Judy Goldstein, Anke Voss-Hubbard, Elizabeth Iglehert, Elizabeth Hughes, Shirley Green, Mr. and Mrs. Heman Blaisdell, Ledyard Stebbins, Ernest and Barbara Smallidge, Margaret Wright, Donald Bryant, Bernice Pierce, Mark Humphrey, Earle Brechlin, John Lynch, Thomas McIntire, Virginia Hyten, Dr. James Murphy, and Hugh Dwelley.

For the quality photograph reproductions shown in this book, we are grateful to Tru Color Studios in Baltimore, Maryland, and Just Black and White Photography in Portland, Maine.

We are deeply grateful to Herbert and Ellen-Fairbanks Bodman for supporting the project from the beginning, writing the yachting captions, and thoroughly reviewing and polishing the manuscript.

Lydia Vandenbergh
Earle G. Shettleworth Jr.

The completion of this book would not have been possible without the support of my husband, David, and children, Christina and Alex, whose consistent encouragement nudged me forward in what seemed an endless project. I hope that this book, and others like it, will continue to keep history alive and captivating.

Lydia Vandenbergh